A
HISTORY OF
CONNECTICUT'S
DEADLIEST
TORNADOES

A
HISTORY OF
CONNECTICUT'S
DEADLIEST
TORNADOES

CATASTROPHE IN THE CONSTITUTION STATE

ROBERT HUBBARD

THE
History
PRESS

Published by The History Press
Charleston, SC 29403
www.historypress.net

First published 2015

Manufactured in the United States

ISBN 978.1.62619.789.3

Library of Congress Control Number: 2014958077

This book is dedicated to the memory of my parents:
Warren Page Hubbard and Pearl Levis Hubbard

CONTENTS

PREFACE

When Henry Isaac Page was thirteen years old, a long roof board landed on his parents' farm in Durham, Connecticut. Wallingford's killer tornado had carried it five miles and lifted it over a trap rock mountain known as the Three Notches. Page was my great-grandfather and was eighty-three years old when I was born. This small, personal connection to the Wallingford tornado was one of the facts I discovered while researching this book.

Additionally, I have small connections with two other major Connecticut tornadoes. In 1979, upon returning from a two-week business trip to California, my plane landed at Bradley International Airport in Windsor Locks, Connecticut. From my window, I could see the scattered wreckage of antique aircraft left behind by the most deadly tornado of twentieth-century Connecticut.

Ten years later, I would experience the aftereffects of the 1989 storm system that affected Litchfield, Waterbury, Hamden and New Haven as I made my daily commute from work. My car was at a standstill for two hours on the I-84 bridge in Waterbury while road crews cleared away the tree limbs and other debris that the storm had just deposited.

Selecting the tornadoes for this book was a fairly easy task. Only a handful of tornadoes in the history of Connecticut killed one person each. (It's possible that a couple others might have resulted in one or two deaths, but the facts are unclear and unverifiable.) Documentation is available to show that three Connecticut twisters have killed more than one person, and this book covers those tornadoes in detail.

My research led me to many libraries, historical societies, museums, town halls, church archives, graveyards, websites and homes of people who experienced nature's fury. I've taken numerous photographs of the places where the greatest Connecticut tornadoes started and ended, the basement of a house along the path of the worst tornado and the final resting places of the victims and the survivors.

In most cases, new construction has left little evidence of these historical events. For example, residents of Wallingford with whom I spoke were surprised to learn the Wallingford Senior Center was built on the site of the only factory destroyed by Connecticut's most lethal tornado.

I've walked countless miles along the paths of these historic storms to understand the layout of the land and to locate the structures and landmarks that have survived. While walking the path of the 1787 Wethersfield tornado, I received a call on my cellphone from the commercial airline pilot who was a hero of the 1979 Windsor Locks tornado. His actions very likely averted the worst natural catastrophe in Connecticut history by protecting his 120 passengers and crew from the tornado.

My most important written resource for the Wallingford tornado was a small book by a local community leader, John B. Kendrick, which was published only a few weeks after the tragedy. *History of the Wallingford Disaster* includes eyewitness accounts of the survivors and descriptions of relief efforts. It is Kendrick who mentions the roof board landing on the Page farm. It is Kendrick who mentions hundreds of other details that would have been lost to history were it not for his diligence.

Another source that I utilized was the federal government's Signal Corps reports on the Wallingford tornado, which were not available to Kendrick when he wrote his book. The Signal Corps was the predecessor of the United States Weather Bureau for nonmilitary meteorological studies.

Additionally, for all the tornadoes in this book, I sifted through numerous contemporary accounts in local, state and national newspapers, as well as books and feature stories that were published throughout the nineteenth, twentieth and twenty-first centuries. For the most recent twisters, I sought out the personal stories of the survivors. The most important resources for the twentieth-century twisters were the people who lost their homes, were caught in a tornado's path or were involved in rescue or cleanup work. I enjoyed speaking with those people. No matter whether a person has witnessed a large or a small tornado, he or she never forgets the experience.

ACKNOWLEDGEMENTS

I would like to thank the reference department at the Wallingford Public Library; Jan Franco at the Meriden Public Library; Rachel Zilinski, curator of the Wethersfield Historical Society; Barbara Goodwin of the Windsor Historical Society; and Pamela Kaczynski of the Peace Dale Library in Peace Dale, Rhode Island.

Also, my thanks to retired United Airlines captain George F. Deihs; Julia McNamara, president of Albertus Magnus College; David Johnson and the Hamden Fire Retirees Association; James Roche Jr. of the Windsor Locks Historical Society; and Keven McQueen, author of *The Great Louisville Tornado of 1890*, which was published by The History Press.

Thanks to meteorologist Geoff Fox; history teacher Randy Stack; Paul F. Flinter, director of Wallingford Adult Education; Maria Paxi, the Archdiocese of Hartford archivist who was helpful in obtaining information on Wallingford's Irish community; and Susan Colberg of the Wallingford Town Clerk's Office, who helped greatly in locating original nineteenth-century Wallingford records.

I appreciate the time attorney Jerry Farrell Jr., creator of the *History of Wallingford* video series, took to read and comment on my Wallingford chapter.

Thanks to the Reverend James Silver; Robert Beaumont, former Wallingford Historical Society president; Doris Bevan, for information on the history of the Wallingford Police Department; and Lauren at the California State Railroad Museum in Sacramento, California. I'm also thankful for the input of Doris and David Maitland, Jerry Nevins, Sister Anne McBride,

Lisa Furman, Rose Lion and Joanne Day, associate director of the Albertus Magnus College Library.

A thank-you goes out to Debra Voelker, Wallingford Senior Center program director, both for allowing me to use postcards from her collection and for arranging my discussion of the Wallingford tornado at the Wallingford Senior Center.

Thank you to my editor, Tabitha Dulla, for her competence and professionalism, and thanks to my project editor, Katie Stitely, for her thorough review of my manuscript.

I appreciate the contributions of those who witnessed and suffered from the tornadoes, especially Carol Bowes, Jane and Stanton Brown, Dave Cermola, Georgia Ferraiolo, Ronnie Ferraiolo, Kathy Martin and Debra Morgan.

Finally, I want to acknowledge the support and assistance of my wife, Kathleen, in editing numerous drafts of this manuscript and walking many miles over sidewalks, forest trails and train tracks in search of the paths taken by Connecticut's deadliest tornadoes.

INTRODUCTION

Mark Twain is reputed to have said, "If you don't like the weather in New England now, just wait a few minutes." Everyone who has lived in these six states knows the truth of the great American humorist's observation. However, occasionally even Twain would be surprised by the extreme unpredictability of Mother Nature...especially if it came in the form of a freak tornado.

If you live in the American Midwest, you probably know, and fear, the tornado as an unpredictable storm of incredible force that must be guarded against. If you live elsewhere, you might think of the 1939 movie *The Wizard of Oz*, the more recent play *The Wiz* or the 1996 movie *Twister*. For five years, the reality television series *Storm Chasers* followed teams of hobbyists in specially equipped vehicles as they intentionally pursued thunderstorms. Their quest was for the ultimate prize—videos of a tornado.

The National Oceanic and Atmospheric Administration's definition of a tornado is: "a violently rotating column of air, usually pendant [hanging downward] to a cumulonimbus [a dark towering vertical cloud associated with thunderstorms], with circulation reaching the ground. It nearly always starts as a funnel cloud and may be accompanied by a loud roaring noise. On a local scale, it is the most destructive of all atmospheric phenomena."

Also known as a twister or a cyclone, a tornado always extends from a thunderstorm to the ground. A condensation funnel is a tapered, funnel-shaped cloud of water droplets that extends down from the base of a thunderstorm cloud. If it doesn't touch the ground, it's called a funnel cloud.

If it does, it's called a tornado. A tornado travels from a few miles per hour to over seventy miles per hour, with an average speed of thirty miles per hour. However, its whirling winds can reach up to three hundred miles per hour. Tornadoes have been known to extend over an area up to one mile wide and can travel on the ground for over fifty miles. Waterspout is a name given tornadoes that form over warm water.

To be visible, a tornado must contain water droplets, smoke, dust and/ or debris. They are usually preceded by lightening, thunder, hail and rain. However, whether a particular thunderstorm will produce a tornado is not known until the moment the swirling winds appear. Tornadoes can occur at any time of day, but most begin between 4:00 p.m. and 9:00 p.m. In the United States, they are most common in the area between the Appalachian and Rocky Mountains—the midwestern, southern and Great Plains states. They are very rare in New England.

Since 1971, tornadoes have been measured according to the Fujita Tornado Damage Scale, which was developed that year by meteorologist and University of Chicago professor Theodore "Ted" Fujita. An Enhanced F-Scale was introduced in 2007. Both estimate winds based

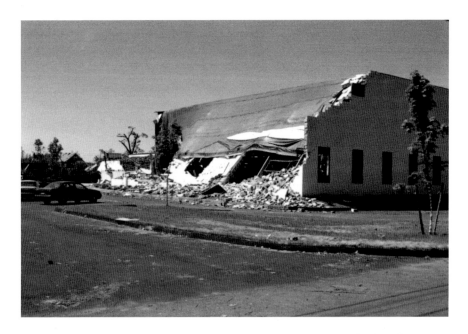

The remains of a building in a Hamden industrial park after a F4 tornado hit on July 10, 1989. *From the Hamden Fire Retirees Association. Photo by Hamden firefighters Raymond Dobbs and John Corbett.*

on the damage incurred. They are used to warn people about the size of advancing tornadoes.

People in New England are familiar with storms that give warning—hurricanes in the early fall and blizzards in the winter. These can, and often do, result in dozens or even hundreds of deaths, but at least they approach with some warning. People have a chance to prepare for the storm, stocking up with food and fuel. They might board up their buildings, get their animals indoors and find shelter in their cellars.

Tornadoes are different. They provide little, if any, advance warning. Although lightning storms can give warning, the vast majority do not produce tornadoes. In fact, the very fact that lightning is such a common phenomena can lull people into a false sense of security. During a lightning storm, the advice is to avoid standing under trees and to go immediately indoors. Few Connecticut residents fret about the storm producing a one-in-a-million chance of a wind funnel that would flatten their houses, yet that is exactly what happened in Wethersfield, Wallingford and Windsor. One minute, families were preparing supper, leading their cows into barns (or, in the twentieth century, pulling their cars into garages) and probably commenting that their crops (or gardens and lawns) could use the extra rain. The next minute, timbers from their attics and branches from their trees were raining on their heads, producing concussions, brain damage and death. The Wallingford tornado lasted less than two minutes, but over thirty people were fatally injured.

In the twenty-first century, instant communications have enabled people to warn others of many potentially dangerous storm systems. Still, tornado prediction is as much an art as a science. In the late 1800s, it was worse: the only quick long-distance communication media were the telegraph and the telephone. The latter had just been introduced in the Connecticut cities of New Haven and Hartford. In 1878, it was in its infancy. (The first telephone directory, with a mere fifty names, was published in New Haven just five months before the Wallingford tornado.) In the 1800s, the telegraph was the sole effective long-distance media. However, it could not yet efficiently gather and disseminate information on emerging storms.

Tornadoes usually cause more deaths in the United States than lightning (about seventy versus sixty per year). They also average more injuries: tornadoes cause about 1,500 injuries annually, and lightning causes only 300.

In the years 1961 through 1990, Connecticut averaged 1.00 tornado per year, which is a rate of about 2.05 tornadoes per year per ten thousand square miles. In comparison, the rates in the continental United States

ranged from .09 per ten thousand square miles in Nevada to almost 9.59 per ten thousand square miles in Florida. The continental states' annual average is 3.06 twisters per 10,000 square miles.

Although serious tornadoes in Connecticut are rare, when someone has seen one, they remember it for the rest of their lives. Husband and wife Dave and Doris Maitland are a case in point. In 1950, eighteen-year-old Dave was working at a factory set on a hill in East Hampton. Looking out at the Starr Brothers factory, which was at a lower level, he was amazed to see its roof rise up as much as one hundred feet into the air. Seconds later, he spotted a pine tree circling the steeple of the Congregational church. Fortunately, the tornado caused only a moderate amount of damage and injured only one person.

Twelve years later, on May 24, 1962, Dave's wife, Doris, was nearby when one of the strongest F3 tornadoes ever to be seen in Connecticut hit Waterbury. She had just started a new job as a schoolteacher and received her first paycheck. After dropping her two children at her mother's, she went shopping. As she drove around a corner, she was confronted with a police roadblock. One officer said she could not go any farther. She asked why, and the officer told her, "Because there's a tornado!" As she drove around the area, she saw one home that had been hit hard; the side of the structure was sheared off, revealing the furniture inside—"just like a doll house."

The 1962 storm killed a sixty-eight-year-old man who was mowing his lawn. He was hit by a falling tree as he was rushing toward his house. It was one of the few documented cases of a Connecticut tornado killing a person.

In developing the scope of this book, I have limited it to the most deadly tornadoes, i.e. those that fatally injured more than one person. Of those, there are three, one each in 1787, 1878 and 1979. Also included is a fourth storm, the Litchfield, Waterbury and Hamden tornadoes of July 10, 1989, because while no one was killed by a tornado in that storm, the one spawned in the Hamden area was arguably the strongest twister in Connecticut's history.

1

THE WETHERSFIELD TORNADO OF 1787

Wethersfield, Connecticut's history of unusual natural phenomena has left scientists with a new appreciation for the word "coincidence." In 1971, a meteorite dropped through the roof of a house on Middletown Avenue. Eleven years later, another meteorite fell through the roof of a Wethersfield house less than two miles away. The only other city or town with two verifiable meteorite strikes is Honolulu, Hawaii (in 1825 and 1949).

The house struck by the 1971 meteorite was next to the site of the South Wethersfield railroad station. Two centuries prior to that, a rare natural phenomenon occurred a mere seven hundred feet away.

A PREMONITION

On Wednesday morning, August 15, 1787, forty-three-year-old Wait Robbins and his sons Wait (who had turned sixteen the day before) and Levi (age twelve) left their home in Wethersfield, Connecticut, on horseback for New Hampshire's Dartmouth College. Founded only eighteen years earlier by a Congregational minister, the college was already on its way to becoming one of the most prominent institutions of higher education in the United States.

The younger Wait Robbins was to be enrolled in fall classes. As they trudged northward, his father had a feeling that something was wrong back home. He stopped short of his destination and, in the morning, headed back

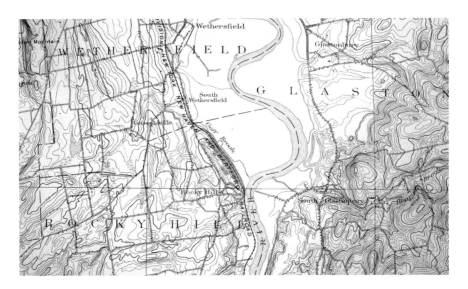

The Robbinses' house was located close to the railroad tracks, approximately between the words "New" and "Haven" on this map. *From the* Topographical Atlas of the State of Connecticut, *1893.*

to Wethersfield. Ten miles north of Hartford, he encountered a messenger who had been sent to locate him. The man informed the elder Wait that a violent storm had killed his wife and one of his sons.

Wait Robbins's wife, Hannah; five of their children (including a five-month-old son); a laborer; and a female servant were in buildings on the Robbins homestead, which was located less than a mile west of the Connecticut River. Unbeknownst to them, a tornado was forming several miles west in New Britain, where it unroofed a barn. It traveled on to Newington, where it swept the roof from a house and destroyed another barn. A boy was blown from his horse and escaped unhurt, but the horse suffered broken legs.

Reverend John Lewis, pastor of the Congregational Society, gave a firsthand account of the tornado in Wethersfield. He stated that, at about 12:00 p.m., an unusually black cloud appeared in the northwest. "Its upper edge was indented and formed irregular columns, something resembling pyramids." The cloud produced a little thunder and rain. Then, at about 3:00 p.m., a black column formed. It was about five hundred feet in diameter and "whirled with amazing velocity and a most tremendous roar. It appeared luminous and ignited, and was charged with broken pieces of fences, and huge limbs of trees, which were continually crashing against each other in the air, or tumbling to the ground." Reverend Lewis went on to write:

This appearance continued but a few moments, when the column instantly divided horizontally at a small distance from the earth—the upper part appearing to rise, while the lower part exhibited the appearance which a huge body of thick smoke would do [if it were] dashed by a strong vertical wind, spreading itself to the extent of sixty to eighty rods [1,000 to 1,300 feet]. At once you might observe it at a small distance forward apparently burst from the ground, like the thickest smoke, spread the above distance on its surface, then whirl and contract itself to the size of the column I now describe; but in no instance did the cloud appear to stoop towards the earth.

In this manner it appeared, with longer or shorter intervals of the compact column, during the whole space in which I have been able to collect accurate information; with this exception only, that in the easternmost part of the observed space, for a considerable distance, it was not seen to be luminous or ignited; though each described its bursting from the earth, as giving them the idea of fire, which they really supposed, until after it was past, consuming everything in its way. It moved in a direction, when first noticed, somewhat to the northward of east, but soon changed to nearly east.

In its swing through New Britain and Newington, the storm did a fair amount of damage, but no one was killed. Then, it hit the homestead of the Robbins family. As the family fled from the house, their laborer raced from the barn. About one hundred feet away from the buildings, the laborer ran past the others and was blown over a fence into a garden and survived unhurt.

Not far from the laborer, ten-year-old Austin Robbins was killed, and his three-year-old brother, Samuel, suffered injuries from which he would die several weeks later. Their mother, Hannah, was blown sixty feet back toward the house and died on the spot. She had held onto her baby son until she died. He was found about fifty feet from his mother. Although injured, he would survive. The two other children ran in the same direction as the female servant and were only slightly injured. The servant was more bruised than the children because she was carried away by the winds.

The Robbinses' house was destroyed, and its adjacent corn house, cider mill house, hay pressing building and a large barn filled with grain, hay and flax were leveled. Of the three ox ploughs in the corn house, one was moved more than six hundred feet; the other two could not be found. A two-foot-in-diameter white oak tree was pulled from the ground and, with an estimated five thousand pounds of dirt clinging to its roots, carried about twenty-five feet.

Approximate location of the Robbinses' house in South Wethersfield. The railroad track was laid a century later. *From the author's collection.*

Location where the Wethersfield tornado of August 15, 1787, crossed the Connecticut River. This view looks out from the Wethersfield shoreline to the town of Glastonbury. *From the author's collection.*

Near the Robbinses' house, the tornado toppled a low stone wall, which included stones weighing several hundred pounds; carried bricks and stones up to 220 yards away; and blew one apple tree almost half a mile. Two of Hannah's gowns were carried by the winds over the Connecticut River and deposited three miles away on a barn in the town of Glastonbury. The barn was owned by Hannah's sister!

COULD HAVE KILLED THOUSANDS

The Robbinses' house was in the northern part of Wethersfield's parish of Stepney. Today, the site of the Robbinses' home is near the Rocky Hill–Wethersfield town line. About eighty years after the tornado, railroad tracks were constructed nearby, parallel with the river. In an article published the Monday after the storm in the *Hartford Courant*, Reverend Lewis stated that if it had passed a mile and a half farther south, it would have hit the center of Stepney Parish and "no doubt" caused the loss of hundreds of lives. He conjectures that if it had hit the center of Wethersfield, it would have killed thousands.

The only residential building destroyed by the tornado was the Robbinses' house. Just before it hit the structure, the twister had adjusted its direction from northeast to east. As we shall see, the Wallingford tornado would make the same northeast-to-east change of direction just before it claimed victims' lives.

The Wethersfield tornado proceeded to seriously damage or destroy several buildings in Glastonbury, demolish acres of orchards and inflict minor injuries on two people. After leaving Glastonbury, it passed through Bolton and ended in Coventry. It was only the second time a tornado caused fatalities in Connecticut; the previous August (1786), a woman was killed by a tornado in Woodstock, which lies in the northeast corner of the state.

Soon after the tornado killed his wife and two of his sons, Wait Robbins rebuilt his house and, in 1789, remarried. He lived until 1826, when he passed away at age eighty-two. William Griswold, one of his descendants, subsequently acquired the house. It stood one-eighth of a mile south of the South Wethersfield train station. It burned down in 1907.

Wait and Hannah's son Levi, who accompanied his father and brother to Dartmouth that fateful day, later graduated from Yale College and became a local farmer. Described as a man of few words and "retiring disposition," he lived to see the end of the American Civil War, passing away in 1866.

THE LAST SURVIVOR

According to an 1873 article in the *Hartford Courant*, the last surviving eyewitness of the Wethersfield tornado was one-hundred-year-old Abigail Broadbent of Wethersfield. She passed away in January 1874.

At the time of the disaster, and for decades afterward, the 1787 storm was called the Wethersfield Hurricane, but today, experts agree that it was a tornado. After killing half of the Robbins family and leveling their house, it remained the deadliest tornado in Connecticut history for another ninety-one years. But it was almost like a trial run for the next killer tornado. The Wallingford tornado would not be satisfied with the sacrifice of one family—it would wreak death and destruction on an entire community.

2
THE WALLINGFORD TORNADO OF 1878

Wallingford, Connecticut's *Windermere Weekly Forum* published "Windermere Lake" by J.J. O'Brien on June 29, 1878:

As pensive I stood, on the banks of the Lake,
That beautiful Lake Windermere,
The sun o'er Mount Tom its exit did make;
And the nightingale's song sounded clear.
As the small boats below, o'ver the water did glide,
And their occupants comfort did take,
While the lads and the lasses, sing songs side by side;
O'er the water of Windermere Lake.

Six weeks later, the most deadly tornado to ever hit New England sprang into existence in the middle of Lake Windermere. According to some experts, if the newly created lake wasn't there, the tornado might not have been as powerful—or as deadly.

On Friday, August 9, 1878, the leaves on the elms, maples and oaks surrounding Lake Windermere were emerald green, and the brilliant sun had brightened the spirits of the residents of Wallingford throughout the day. A newspaper article later stated, "The afternoon was as pleasant as one could wish."

Local industrial tycoon Samuel Simpson was home with his wife and family in a large Colonial house on Main Street, a tree-lined thoroughfare

that was the first street planned out when the town was settled over two centuries ago. Main Street was the location of the most prestigious addresses in town. Many of the women in the nearby working-class neighborhood were home and busy with household chores. Most of the men and younger, employed women were working at the local factories.

The backyard of the Simpson house, as well as many others on the west side of Main Street's north end, gently sloped downward for about a quarter of a mile. At the foot of the hill, on land so flat it was named the Plains, stood the small, wooden homes of first- and second-generation Irish Americans. An 1892 history of New Haven County called Wallingford's Plains "the largest level belt and the most extensive barren lands in the state."

The Irish living on the Plains were separated from the Main Street homes by dozens of acres of rich orchards. They differed from the Main Street elite in religion, accent and financial status. The Irish rented many of the small homes on the Plains from the residents of Main Street or its parallel thoroughfare, Elm Street.

Every month or so, the real estate owners, or their legal representatives, would make the rounds of the Irish dwellings on North Colony Street, Christian Street and Wallace Row. They would chat with their renters and collect the rents. Many of the Irish were able to pay the rental fees out of money earned in the metal works factories in Wallingford or the neighboring town of Meriden.

The Way Thunderstorms Were Supposed to Act

On Friday afternoon, clouds gathered over the mountains west of Meriden. In Wallingford, people repeatedly checked on the darkening of the northwestern skies, closed their wooden window shutters, brought laundry indoors and herded livestock into barns and sheds. Many factory workers hurried home from the Meriden and Wallingford factories over the dirt roads or alongside the railroad tracks.

Everyone in town heard the claps of thunder, and most stared up at the increasingly frequent lightning bolts. Some noticed a second front of clouds, less dark than the first but still ominous. It was sweeping in from the southwest. They expected one or both sets of clouds to blow away to the northeast. That's the way thunderstorms were supposed to act. That's the way they always acted in Wallingford.

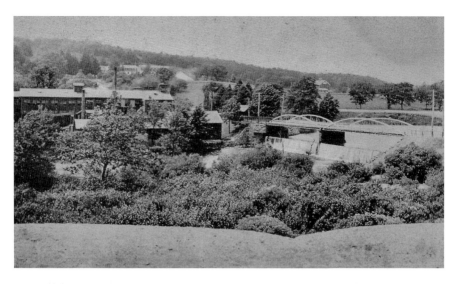

The Wallingford Perfectionist Community's main factory, which lost its roof in the tornado, and Community Lake (Lake Windermere) with its dam. *From D. Voelker's postcard collection.*

Concerned about getting wet or being exposed to bolts of lightning, residents headed inside to collect umbrellas or join their families around the warm cooking stoves. There was no way they could have known that sitting by those stoves would prove to be as dangerous as standing on the tracks in front of one of the massive steam locomotives that rattled their houses several times a day. A few minutes later, some of those stoves would be lying in the mud hundreds of feet away, while pieces of the stovepipes would be scattered over pastures miles to the east.

One young Irishman, a factory worker from Meriden, had only one objective as he watched the storm clouds gather—to get his rowboat to shore. Twenty-three-year-old Daniel O'Reilly was in the middle of Windermere Lake, which lay on the west side of the train tracks. Also called Community Lake, it sat barely half a mile from the Irish homes. O'Reilly's mother lay on her sick bed in her small home on the Plains, and he took the most direct route to her—across the water.

Wallingford lies in the valley of the Quinnipiac River, a forty-five-mile-long, north–south waterway that terminates in New Haven Harbor. A place with a rich and colorful history, Wallingford is the birthplace of Lyman Hall, a signer of the Declaration of Independence, as well as the site of Choate Rosemary Hall, a top-tier college-preparatory school that counts President John F. Kennedy among its alumni. It was also the home of Winifred Benham

and her thirteen-year-old daughter, Winifred Benham Jr., who were accused of witchcraft by other residents of Wallingford. In 1697, they became the last two people tried for witchcraft in New England. They were acquitted.

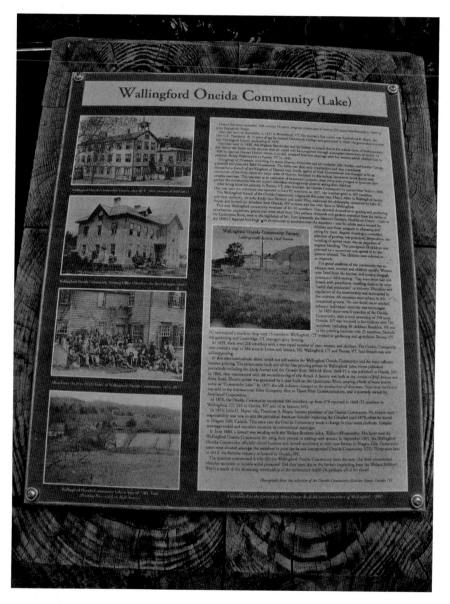

Plaque at Community Lake that describes the Wallingford Perfectionist Community. *From the author's collection.*

WALLINGFORD'S DIVERSE POPULATION

By 1878, Wallingford had about 4,500 residents. The poorer ones lived in the Plains, which was between Community Lake (Windermere Lake) and Main Street. The west side of the lake was home to a religious cult, the Wallingford Perfectionist Community, which had dammed the Quinnipiac River to provide waterpower for its factory. By the 1870s, its business was in full operation, publishing books and newsletters and manufacturing silverware and animal traps.

On the day of the tornado, Daniel O'Reilly obtained permission to pick some apples at an orchard owned by the Perfectionist Community and then set off in an old rowboat to cross Community Lake in the direction of his mother's house. As he soaked in the sun, O'Reilly no doubt glanced westward toward the Perfectionist Community's buildings and its windmill, which dominated the landscape. At the north end of the lake was the Perfectionist Community's small, brick factory building, which had recently been converted from a paper mill to a silver tableware factory; it was run by German immigrant George Grasser, who was not a member of the cult.

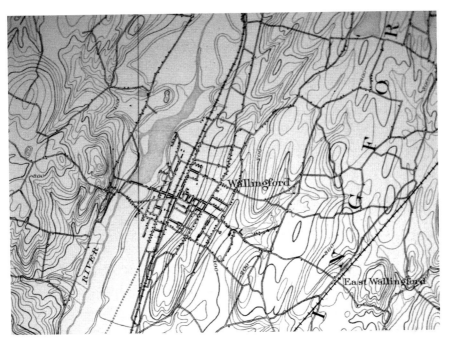

Although this map was created about fifteen years after the Wallingford tornado, it shows Community Lake as it existed at the time of the storm. *From the* Topographical Atlas of the State of Connecticut, *1893.*

Toward the east, O'Reilly could see the poorest section of town—the Plains. Only the railroad tracks separated it from the lake. If trees weren't obscuring his view too much, O'Reilly would also see the steeple of the wooden Catholic church that the Irish had constructed yards from the railroad tracks. It was surrounded by a small cemetery, filled mostly with Irish men and women who had immigrated to America and their children, many of whom had died because of infectious diseases, poor nutrition and the lack of medical care.

The First Victim

From O'Reilly's vantage point in the boat, he would have seen the storm clouds gathering and moving closer from the northwest and the southwest. Soon, lightning bolts were striking down from the dark northwestern clouds—not the common zigzagged flashes but lines of electricity pointing straight down. Most likely, he saw the blades on the Perfectionist Community's windmill

The approximate place where the Wallingford tornado formed. This photograph was taken at 6:15 p.m. (7:15 DST) on August 9, 2014, exactly 136 years after the tornado. *From the author's collection.*

spinning faster and faster. The southwestern storm clouds were coming over the hills, too. O'Reilly's boat was buffeted by the crosswinds.

While many residents followed the incredibly black cloud in the northwestern sky, they didn't know that the storm system had already caused damage in Connecticut. It made its first appearance at South Kent, Connecticut (thirty miles northwest of Wallingford), along its border with New York State. There, the storm blew down or unroofed several houses and barns. It also carried a large oak tree such a distance that investigators could not determine its original location. Like Wallingford, western Connecticut experienced severe thunder, lightning and torrential rain.

A little later, the storm touched down two miles west of Waterbury (sixteen miles northwest of Wallingford), where it blew off one roof, knocked over chimneys and broke off tree limbs. Minutes later, an orchard in Cheshire (six miles west of Wallingford) had trees knocked down, but no one observed a tornado's twisting movement. In Meriden, the slate roof of a Bradley and Hubbard Manufacturing Company building was wrecked, and the adjacent forty-foot flagpole was struck by lightning.

Most Wallingford residents first became aware of a storm when they saw the clouds over Meriden. Some Wallingford people reported two clouds of "inky blackness" over the Meriden mountains with a "snowy white" cloud between them. Since the wind was coming from the southwest, few were concerned. They were sure the winds would blow the storm north, away from town. At worst, they expected only a bad thunderstorm. After all, outside of the dark clouds, clear sky was visible.

Then, the thunderheads approached Wallingford with "lightning rapidity." Some witnesses said they were the most dreadful clouds they had ever seen. At about 5:00 p.m., thunder and lightning shook people into an awareness of the impending storm. Still, because of the wind direction, there was little concern. Suddenly, at 5:30 p.m., the wind changed direction, blowing to the west. Then the rain started, and lightning became more frequent.

As the storm was brewing, the Wallingford Perfectionist Community let the young Irish female factory workers leave before their normal quitting time of 6:00 p.m. Unfortunately, they arrived home just minutes before the tornado swept through their neighborhood. For many, the safest places—their homes—were, in fact, the most dangerous places to be. It turned out that the people who survived were those who remained at their workplaces in Wallingford or Meriden.

One workman, walking south toward the center of Wallingford from Samuel Simpson's factory, spotted a house on fire on Colony Street.

Apparently, it had been struck by lightning. As the rain picked up, it extinguished the flames.

Back at Community Lake, Daniel O'Reilly rowed for the eastern shore. As both storms were heading toward him, he knew he wouldn't be able to make it. Mere yards behind O'Reilly's boat, a dark funnel of swirling wind formed and sucked lake water into the sky. The cylinder of water was higher than any building he had ever seen—or even heard about. Witnesses estimated the waterspout reached as high as a twenty-five-story building. Others claimed they could see the dry lake bottom as all the water was pulled upward.

Many years later, O'Reilly described the event:

> There was a whirlpool started, and it came directly toward my boat. I dove overboard and kicked the boat in the direction of the approaching whirlpool. I managed to scramble ashore and lay down. When I opened my eyes, I saw the ground covered with wood and broken trees and a horse came tearing toward me, having escaped from a barn that lay flat. My boat was torn to pieces, I should judge from the boards scattered around. The wind continued to blow a gale and water poured down in buckets.

The sand and pebbles, stirred up by the storm, swirled around, whipped him and left deep impressions on his body.

When O'Reilly reached his mother's home, he found sixty-six-year-old Catherine O'Reilly in bed and everything in the room covered with pieces of wall plaster. A tree limb had broken through the side of the house and stuck out of the wall just above her sick bed.

While O'Reilly's boat was being tossed along by the winds, an empty iron rowboat on the lake was lifted up and thrown to the beach, landing over two hundred feet away from the water. Although it was still in good shape, one of its oarlocks had been pulled off and sent in an opposite direction, embedded into the ground on an island on the east side of the lake. Nearby, the Perfectionist Community's spoon factory was ripped to shreds. When the storm passed, O'Reilly stood up to find the four-story-tall high school, one of the two largest buildings in town, missing from the horizon.

In the Yalesville section of Wallingford, the son of the Meriden mayor (Mayor Lewis) saw what he believed were two storms colliding—one from the north and another from the southwest. They converged at Community Lake. About a mile away, the Simpson factory worker, now nearer town, thought he saw a sheet of heavy rain where the storms butted heads. The lake, in the words of another observer, "became a seething whirlpool."

THEY THOUGHT JUDGMENT DAY HAD ARRIVED

Some witnesses stated they saw the waters of the lake divide, rolling up on each side and revealing the dry lakebed beneath. Today, it might be likened to the scene of Moses parting the Red Sea in Cecil B. DeMille's classic film *The Ten Commandments*. Upon seeing the dark storm clouds approaching, the incredible lightning and the formation of a tornado funnel, more than one person later said they thought Judgment Day had arrived. From his position on the veranda of the Wallingford Perfectionists' main building, Perfectionist Community leader George Noyes Miller (1845–1904) was amazed by the storm's formation. This was not the only occurrence that could be labeled as one of Biblical proportions, as the people of Wallingford would soon learn.

There is little chance the residents of Wallingford knew much about tornadoes. However, many people in Wallingford's Plains must have been aware of whirlwinds. On May 19, less than three months before the tornado hit, a thirty-foot-in-diameter whirlwind appeared on the Plains and drove a column of sand at least three hundred feet into the air. It was so dense that it was seen from two miles away.

Now, on August 10, it was about 6:15 p.m. when the two storms met over Community Lake, at a spot about an eighth of a mile north of the Perfectionist Community's main factory. The first structure destroyed by the tornado's winds was the Perfectionist Community's windmill, which was about four hundred feet north of its main residential building. The winds then toppled several large trees before they destroyed the spoon factory. It was a one-and-a-half-story structure that was twenty-two feet wide, twenty-five feet long and twenty-eight feet high. Its roof was blown over a barn and a garden and deposited at the edge of the lake.

Nearby, Palmer Foster was at his barn unhitching a horse from a light lumber wagon. The wind blew him and the wagon thirty feet down the bank to the lake. He lived. Minutes later, across town, Michael Kelly's buggy was blown over another thirty-foot-high bank by strong winds. He also survived.

From Community Lake, the water spout moved east up a thirty-five-foot-high bank on the east side of the lake. There, it pulled up trees and left them pointing east. The width of its destructive path was about four hundred feet at this point.

The Foster and Bidwell families each owned a home on Community Lake. Sixty-seven-year-old Elizabeth Bidwell was in her kitchen babysitting her two- and four-year-old grandchildren, Edna and Russell, while making

Near the west end of Parker Street, the tornado turned toward the east and climbed the bank out of Community Lake. *From the author's collection.*

tea for her son-in-law, stone and brick mason Jessie, who was expected home from work shortly. As the storm passed by, it splattered rain and sand against the blinds of both homes.

Foster recalled that when the cloud passed her house, they were enveloped in a "mist or fog." Other than minor damage to the Fosters' chimneys and a couple blown-over apple trees, both families came through unscathed. The tornado had not seriously hurt anyone yet.

As the tornado rose to higher ground, it emitted a sound like a locomotive. Outside of this path, no trees were uprooted. Within it, trees were pulled up by their roots and, in some cases, scraped the embankment as if they were plows. The only trees that escaped destruction were some small oaks that were flexible enough to bend with the wind.

For some reason, after traveling north up Community Lake, the twister changed direction. From a northeastern path, it turned due east and raced toward Colony Street, which was the main north–south thoroughfare. It was also pointed directly at the congregation of houses that made up the Irish community on the Plains.

"ONLY HERE OR THERE COULD A PLANK OR BOARD BE FOUND"

The winds ripped into the house that Michael Toohey and his family were renting. The house stood about three hundred feet west of the railroad tracks (probably on the site of today's Parker Place Apartments on Parker Street). Within ten seconds, the house was split into thousands of pieces, some of which were flung to the ground while others were pulled up into the funnel, mixed with other debris and carried eastward. Visitors later stated, "Only here or there could a plank or board be found."

Michael's wife, Catherine, who was inside with her children when the house was hit, was pulled out of the building and lifted over the railroad tracks. Her body landed next to Colony Street, over seven hundred feet away. Those who saw the fifty-year-old woman's corpse declared that it seemed every bone in her body had been broken. One witness described her skull as a "pulpy mass" and revealed that it was connected to her body only by skin.

The tornado passed over this location, going west to east (left to right in this picture). The building on the left is near the site of Michael and Catherine Toohey's house. *From the author's collection.*

It's believed that the telegraph wires, which ran parallel to the train tracks, cut Catherine Toohey. Later, when undertaker Benjamin Sutlief was arranging the first twenty-four bodies in rows at a makeshift morgue, he found there was one he could do nothing with—Catherine Toohey's. It was so mangled he finally ended up only wrapping it in a cloth.

Twelve-year-old John Toohey fared better than his mother—he was blown up into a tree and was caught in its branches. He suffered only a broken arm and bruises.

While the Toohey house was being obliterated, a wagon down the street, near the train depot, was overturned. The only home close to the Toohey residence was James Holl's house, which, at the time of the storm, was occupied by several people. None was seriously injured. John Lewis's house "some distance" to the south was moved off its foundation, while barns and sheds nearby were totally destroyed. Again, no one on that property was injured. It was not the last time that great damage would be done to a person or property while a few feet away another person or building would be virtually untouched.

When it crossed the railroad tracks, the tornado was about 600 feet wide. Before it reached Colony Street, it suddenly widened to between 700 and 750 feet. The only growth here was grass and corn, both of which were little affected by the winds. Knocking over twenty-five telegraph poles and about 500 feet of wire, communications with the state capital of Hartford, to the north, and the large port city of New Haven, to the south, were severed.

As the storm was approaching, Fredric Littlewood and his wife, Maggie, were walking home. Frederic left Maggie at Thomas and Alice Rynn's house next to the cemetery and continued home to get an umbrella. He never reached his house. After the tornado passed through town, his body was found in the gutter on the west side of Colony Street. It was only a little south of Parker Road and the Catholic church. Apparently, a flying board hit him, as his head was crushed and his jawbone had broken through the skin. Yet he was sitting upright in the gutter when found.

After learning of her husband's death, Maggie Littlewood rushed home, only to find her ten-year-old son, Johnnie, among the debris of their crushed house. She took him to a neighbor's house, where rescuers found them lying on a mattress. The boy was mangled and bleeding with massive head injuries.

Maggie never saw her husband's body before its burial, since she needed to accompany her son to the hospital in New Haven. She stayed with him until he passed away three days later. Apparently, Maggie was pregnant at the time, since the 1880 United States census lists her living alone in Wallingford

with her one-year-old daughter, Bessie. Another pregnant woman, the wife of victim John Paden, had both legs broken above the knees and suffered a miscarriage shortly after the disaster.

THE MOONEYS

After killing Catherine Toohey, the tornado's funnel struck the Mooney house, which was just north of the Holy Trinity Church. Nearby, seventeen-year-old Matthew "Mattie" Mooney was walking home from work along the railroad track. Two minutes later, he lay dead in the gutter of Colony Street, three hundred feet from his house. In the process of walking home, he had been picked up by the tornado and thrown over four hundred feet. Like in Catherine Toohey's case, his head was barely attached to his body.

Minutes later, searchers found the lifeless body of Mattie Mooney's brother, John, in the Mooney cellar, which was no longer covered by the house. John's twenty-one-year-old wife, Mary, held the dead body of Mattie and John's nine-year-old sister, Nellie. Mary would also die in a short time. The Mooney's mother, Margaret Mooney, aged fifty-two, was found dead outside the house.

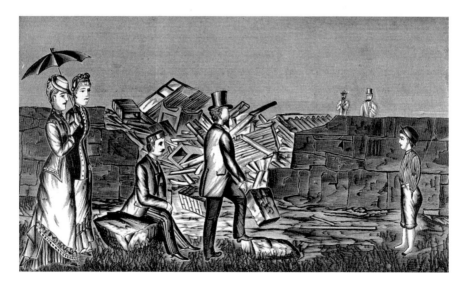

A drawing created immediately after the tornado, which shows the pile of lumber and debris that had been the old Holy Trinity Catholic Church. *From* History of the Wallingford Disaster.

John's five-month-old son, Matthew, was sent to New Haven Hospital, where he died three weeks later. His body was interred with the other five members of the Mooney family in the Holy Trinity Church Cemetery. The only family member to survive, Edward Mooney, was at work in his shop during the storm.

From the Mooney house, the tornado moved onward to the one-hundred-by seventy-five-foot wooden Holy Trinity Catholic Church and obliterated it. The day after the storm, a newspaper reporter described the wreckage: "The Catholic church presented an appearance of utter demolition. It seemed not only to be thrown down, but broken to splinters and beaten down into a flat heap."

Father Hugh Mallon, Holy Trinity's pastor, along with several other men, had worked on the old church that day. However, Mallon had been called away on some other matter that afternoon, and all quit work, narrowly escaping death.

259-Mile-Per-Hour Winds

All of the large monuments in the cemetery adjoining the church were toppled and left pointing north, while the shorter tombstones were knocked over to the east. It appeared they had been lifted off their bases and then set down, since most of the bases were free of chips or marks. The heaviest stone, which measured two by two by four feet and weighed 2,688 pounds, was blown from its base without either it or its pedestal being chipped. The United States Signal Corps calculated that this would have required 259-mile-per-hour winds.

The winds proceeded through the flat, sandy lands. Now in the shape of the traditional whirling cone, the tornado destroyed rows of wooden houses with brick foundations.

The four streets hardest hit were the north–south Colony Street and three roads that branched off of it to the east at ninety-degree angles. Two of these roads, High Street and Christian Street, extended all the way east to Main Street. The third, Wallace Row, ran between and parallel to them and was less than half the length of the other two. The tornado swept down the full length of each of these side streets as it ran in its west–east direction. Few houses on these streets escaped total destruction.

Observers later noted that trees were uprooted rather than merely overturned. A string of six houses on Colony Street, immediately north of

The original part of Holy Trinity Catholic Cemetery, looking east. Wallace Row starts between the two houses on the right. *From the author's collection.*

the cemetery, also experienced more than their share of fatalities. Only one house on High Street and one on Wallace Row survived total destruction. In this thirty-five-acre area of level land, the tornado flattened about thirty houses and claimed most all of its victims. William A. Glassford's United States Signal Corps report stated that Wallace Row "was so thoroughly destroyed that only thickly-spread debris showed the place where the houses once stood."

According to John Kendrick's book, "The Coughlin family suffered severe injuries; but in this family only one life was sacrificed to the storm demon." The violence of the tornado had hurled fourteen-year-old Katie Coughlin through a window on the upper story of her house. Death was instantaneous. A flying timber probably struck her, for the upper and back portions of her head were entirely gone, and her brain was oozing out. Katie Coughlin was later buried in the Holy Trinity Church Cemetery.

When the storm was approaching, eight-year-old Johnnie Hayden had gone out with seventeen-year-old Thomas Cassen to gather in their cows. Both were found dead, with Cassen showing no external injuries. His mother, Maria Boyle, age forty-four, was killed instantly.

Thirty-eight-year-old Joseph Huldie had just returned home from his job in the glass shop and was holding his seven-month-old baby. Hearing the

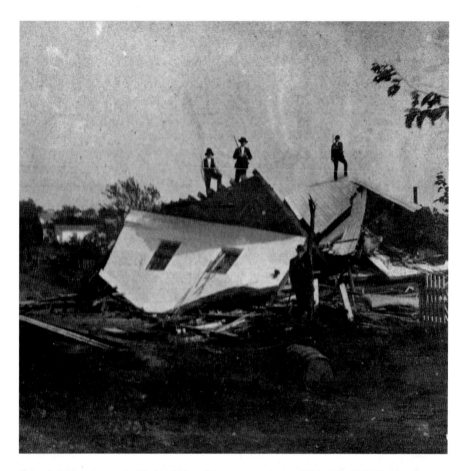

One of the houses on the Plains. Taken from a stereoview published by D.S. Camp of Hartford. *From the author's collection.*

sound of heavy rain, he handed the baby to his thirty-five-year-old wife and went upstairs to close a window. When he returned, he found his wife dead but still holding the baby, who was also dead. Their five-year-old daughter, Nellie, also was killed. Two days later, the mother and her infant son were buried together in the same coffin.

Although women and children made up the majority of the victims, some men were home at the time, and they, too, were helpless against the storm's power. John Paden, a forty-five-year-old veteran of the Civil War (Connecticut Volunteers), was killed by the tornado. Alive when found, he was carried to his brother's home but lived only another hour. He was later buried in the Holy Trinity Church Cemetery.

KILLED BY THE TORNADO

The tornado killed forty-four-year-old Ellen Lynch—the wife of John Lynch and a native of the parish of Tulla, County Clare, Ireland. When the tornado struck her house, she was at her sewing machine. She and her daughter were thrown toward their stove. Then, the winds picked them up, and Ellen was tossed one hundred feet from the house. She died shortly afterward. Her large obelisk in Holy Trinity Church Cemetery reads: "Killed by the Tornado." Her husband lived into the twentieth century, dying in 1903 at age seventy-eight.

Their daughter, Maggie, lived but was in constant pain with severe damage to her face, back, leg and foot. Perhaps most worrisome of all were the possible internal injuries. Unfortunately, this was seventeen years before X-rays were discovered.

At the corner of Colony and High Streets, only yards northeast of the church, the tornado dropped the remnants of the three houses it had demolished, as well as the body of Catherine Toohey. On Colony Street,

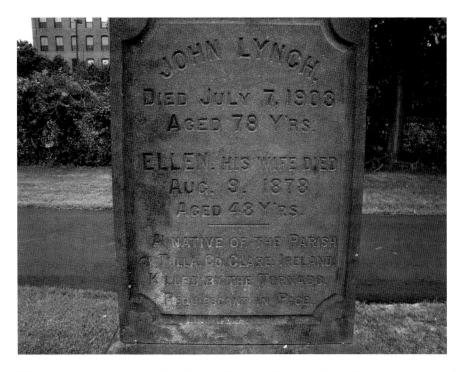

Ellen Lynch's grave marker in Holy Trinity Cemetery. *From the author's collection.*

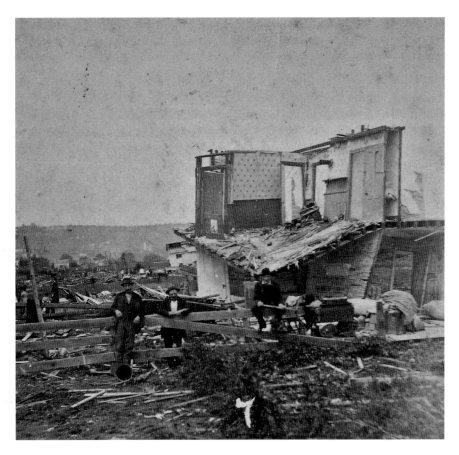

The John Simmons house as displayed on one of New Britain photographer N.R. Worden's stereoviews. *From the author's collection.*

part of the east side of Conrad and Kate Tracy's roof was torn off. The Saunders' house was completely destroyed, with parts being found as much as one hundred feet away. The Condon and Ginty houses were destroyed. Dead chickens lay around with half of their feathers missing. John Simmons's house was broken apart, with the four walls spreading out on the ground like a disassembled cardboard box. The internal wall partitions remained standing.

One witness, F.T. Riley, a worker at Simpson and Hall, stated the storm stirred the sand from the Plains high into the air. Riley took refuge in Allen's store on Center Street, which was about a mile south of the tornado.

The noise of the storm is what first attracted many people. Dr. Benjamin Harrison, who was in his house was on Main Street, south of the track of the

John Ginty house on the Plains. *From* History of the Wallingford Disaster.

tornado, was drinking tea when he heard, according to a Signal Corp report, "a great noise, as the rumbling of a wagon over cobblestones—crashing, crushing, roaring noise, as the waters of the Niagara going over the falls. It was very dark; black as night."

The tornado headed up the hill, reaching Main Street at the summit. Its track was now close to 1,200 feet wide, but it wasn't destroying entire structures, only housetops. The tornado broadened its path and took down more trees, many of which had their roots washed bare. At the time, some people said water carried from Community Lake had cleaned the roots and contended that, two miles east of the lake, fish were found in John Munson's orchard. Others disputed the report of fish and insisted that the extraordinarily heavy rain immediately following the tornado had washed the roots.

I.A. Reed of the Signal Corps found a sharp piece of lumber that was embedded two and a half feet into the ground. It was from one and a half to four inches wide and half an inch thick. In other places, a wooden splinter was found inserted through a lead pipe, and a shingle had passed through four and a half inches of wood.

At the top of the hill, the twister hit the seven-year-old North Main Street High School. Sitting at the northwest corner of Main and Christian Streets, the four-story brick structure with ornamental brownstone trimmings was surrounded by the homes of Wallingford's most affluent citizens. Measuring

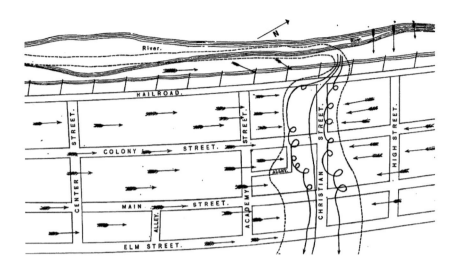

Tornado track diagram created shortly after the Wallingford tornado. Not shown is Wallace Row—which was between, and parallel to, Christian and High Streets. *From the* Annual Report of the Chief Signal-Officer, *1878*.

seventy by eighty feet, it included a partially aboveground basement, two middle stories and a top mansard story. The winds ripped off its top two stories and part of the second floor and tossed wooden beams hundreds of feet into the air. Pieces of the building were later found spread out for miles to the east. An elm tree next to the high school, one of the largest in town, was pulled up by its roots and tossed twenty feet away.

Unlike the inexpensive homes on the Plains, the houses at the crest of the hill were, for the most part, large, new and well constructed. Although they could better withstand the winds, many had their roofs or upper stories broken apart and tossed hundreds of feet into the air. On Main Street near the high school, the Parmelee and Hall family houses had their roofs blown off, and John Munson's place was demolished. In each of these houses, one woman was found buried in the rubble. All were successfully rescued.

In an interview that appeared in a 1950 issue of the *Wallingford Post*, a local paper, manufacturer George Grasser's son, also named George, described how, at age thirteen, he had weathered the tornado at his family's Christian Street home, which was on the southern edge of the tornado's path. As the tornado was killing a dozen neighbors on parallel Wallace Row, young George was trapped in his father's barn. It would have collapsed on him, except for its full load of hay, which held up the roof. At the time of the

interview, Grasser was eighty-five years old and lived in the same house that had weathered the storm seventy-two years earlier.

Grasser's case was not unusual. Research for this book has shown countless cases where survivors of tornadoes had lived only because pieces of wooden walls or other solid obstacles, such as large pieces of furniture, fell at an angle and protected people from falling roofs, walls and tree limbs.

In the twenty-first century, the United States government's Centers for Disease Control and Prevention (CDC) recommended "that people in the path of a tornado find a shelter or a tornado-safe room. The safest place in the home is the interior part of a basement. If possible, get under something sturdy such as a heavy table or workbench. If outdoors, lie down in a gully or ditch." Many of the Wallingford tornado's survivors had found such locations.

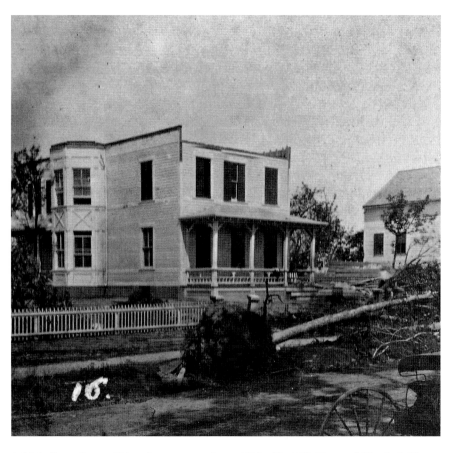

A Main Street house. Taken from a stereoview published by D.S. Camp of Hartford. *From the author's collection.*

On Main Street, two houses owned by fifty-four-year-old farmer Samuel Parmelee were flattened, Henry James's house was partially destroyed and John Ives lost his roof. Harry Joel's house was destroyed, and Joel was injured when he was blown against a tree.

"We Can't Live Here Long"

On the west side of Main Street, the high school's neighbors, Ortheniel Ives (on the south) and insurance agent William M. Hall (on the north), each lost the top floors of their three-story homes. Fortunately, no one was in the upper stories when the winds took their toll. At the time the tornado hit, Hall was rushing from his barn to the house. The next thing he knew, he was in the middle of the street, with no memory of how he landed there.

North of Hall's place stood the John Munson house. It was virtually erased from the landscape. From his window, Munson saw Hall's barn flying toward his property. A Wallingford selectman, warden and savings bank treasurer, Munson was one of Wallingford's well-known citizens. During the height of the winds, he clung to a door casing. However, it didn't keep him from being dropped to the basement.

Throughout the storm, Eliza Munson, John's wife; their daughter; Sarah Fields, an invalid woman; and a servant were stuck in a different part of the house. Upon digging his way out of the basement, Munson shouted for them. He received no response. He went closer to the wreckage and yelled again; still no reply. Finally, he heard a weak voice say, "We are all alive." But then it was followed with, "We can't live here long." The four women were trapped in a small space between the two floors of the house. They couldn't even see daylight.

Munson and some neighbors obtained axes and began cutting the floor boards until a woman cried out, "My God, don't chop or you will split our heads open." Unfortunately, the would-be rescuers could not make out the muffled words. As one of the men raised an axe again, the woman cried out, "If you will desist, we will show you where our heads are." She then poked a small piece of wood through the floor. It came out at the exact spot the axe blade would have fallen. The men then used saws and cut and pried up the floorboards, freeing the women, all of whom were only bruised.

Later, a box containing two gold watches, which were originally in a drawer in the Munson house, were found in the middle of Main Street. Even more

Samuel Simpson, business owner and head of the tornado relief committee. History of New Haven County, Connecticut, *1892.*

surprising, a scrapbook and notes belonging to John Munson were discovered eight miles away in the town of Durham.

One of Main Street's most prominent residents, Samuel Simpson, had sat by a window calmly watching the clouds to the north darken and the lightning bolts become more frequent. It was only after his chimney came crashing down and his family rushed to him with alarm that he looked again out of the window. He "could not believe that he saw correctly" as he viewed the incredible devastation. Later, Simpson was chosen to serve as president of the disaster relief fund executive committee, and it was at Simpson's suggestion that the history of the tornado be written.

The whirling motion of the tornado was felt and seen by German-born Herman Vasseur. On the way home from work as a designer at the

Simpson, Hall, Miller and Company factory, he saw a "black and heavy cloud hovering over the plains." He hurried along, as it appeared to him that two thunderstorms were going to meet. Arriving home, he found his four family members frightened and reassured them that it appeared the looming storm would be more wind than rain. Besides, their house, on the top of the hill, was one of the most solidly constructed homes in a neighborhood of well-built structures. Soon, they heard a "terrible roaring noise" outside.

Before the Vasseurs could move anywhere, an eight-foot-long wood plank crashed through the west side of the house. In the words of fifty-one-year-old Vasseur, as the tornado winds attacked, the house reeled "back and forth, as a drunken man would" and seemed to swing as if on a pivot. Flagstone slabs on the three chimneys of the house were carried in three directions: west, east and south. Since a nearby eight-foot-high chicken coop was undamaged, it appears the winds were a number of feet off the ground at this point. Vasseur's sixteen-foot by twenty-five-foot, twenty-foot-high barn was transported one hundred feet south, with its roof landing another thirty feet east of it. One of his apple trees, estimated to weigh 1,500 pounds, was carried twenty feet to the north.

When the roaring noise of the tornado stopped, heavy rains began. Fortunately, they put out the fires that had started from overturned lamps and stoves.

On Elm Street, which is to the east of Main Street and approximately parallel to it, a ten-foot-in-circumference elm tree was broken off about four feet from the ground; another elm, nine feet in circumference, was broken off at nine feet. Other elms on the street were stripped of branches or pulled up by their roots. A few houses in the area were broken up and the pieces so mixed up by the tornado that it was impossible to determine the origin of the debris.

One resident of North Elm Street who received a scare was thirty-one-year-old, Ireland-born Nicholas Bridget. A night watchman at a local factory, he had already left for work when the tornado struck. He rushed home to check on his wife and four sons, who were all less than six years old. Fortunately, they were fine, but their house was ripped apart. Bridget's twenty-eight-year-old wife, Margaret, reported that she ended up "standing in the yard trying to find the house." The only furniture they could find was one chair.

At the crest of the Main Street hill, in an area of about 125 by 250 feet, the storm appeared as two 50-foot-wide whirlwinds. At the corner of Main and High Streets, Samuel Peck's house lost its chimneys, and the roof of the

A huge tree on or near Main Street or Elm Street. *From* History of the Wallingford Disaster.

adjacent barn was thrown into the street. As the tornado proceeded toward Durham in an east-southeast direction, it left in its wake heartbreak, broken lives and debris as far as the eye could see. Today, Whirlwind Road in east Wallingford serves as a reminder of the disaster.

As the funnel moved beyond Wallingford, it rose higher and was less of a threat to eastern Connecticut towns. A United States Signal Corp report, released several months after the tornado, estimated that the cloud above the tornado's funnel ranged from seventy-five to one hundred yards in width and five hundred to eight hundred feet high.

For days, visitors could view the wide assortment of items that the storm had scattered around east Wallingford. Included were shingles, furniture, laths, clothing, books and dead chickens. A piece of the high school's tin roof was found twelve miles away in Haddam.

One Meriden woman, Hannah Donovan, came to Wallingford to search for remnants of Holy Trinity's organ. Years before, the thirty-six-year-old instrument had been given by Meriden's St. Rose Catholic Church to Holy Trinity. St. Rose choir member Donovan had grown attached to it. Unfortunately, she could find only small pieces of the organ keys, which she kept as mementoes.

Sergeant I.A. Reed of the Signal Corps estimated that the destructive path of the tornado was between 1¼ and 1½ miles long, with the width

being 425 to 450 yards. He also figured the center of the path to be 75 to 90 yards wide with 150- to 175-yard-wide less powerful tracks on each side. He stated that the direction of the tornado changed twice after it first formed over Community Lake. From the lake, it traveled from southwest to northeast until it reached a spot near the railroad tracks. Then, it changed course to an almost exact west–east direction. After it passed Elm Street, it turned again, but only slightly, to an east-southeast direction as it traveled over the mountains to the town of Durham.

Reed, after extensively interviewing witnesses, came to the conclusion that little rain fell as the tornado swept through town, but torrents came down immediately afterward. The fact that various papers were dry enough to be picked up by the winds and transported east to Durham and other Connecticut towns seems to support this conclusion. One piece even found its way to Rhode Island, as we shall see.

Samuel Peck had a good view of the sweep of the tornado from his house on the corner of High and Main Streets. When, from his backyard, he saw two storms coming together over Community Lake, he was reminded of a storm twenty or thirty years earlier during which clouds from the north met clouds from the south. That time, however, it only resulted in a major hailstorm. In contrast, Peck now saw a waterspout form over the lake and watched in fascination as it approached his house. His family cried for him to seek safety in the hallway, but he insisted on watching the storm. It broke windows on the north and south sides of his house but none on the east and west. Peck added that no rain fell until after the tornado passed by.

Immediately after the tornado left, Myron Kingsley, manager of the Perfectionist Community's main factory, raced to the Irish neighborhood to check on the girls he had released early from work. When he found Ann O'Rourke, he thought she was dead because she was covered up in the same way as nearby corpses. When he discovered she was alive, he left her at Mrs. Thomas Kennedy's house. Kingsley returned to the Perfectionist Community and brought back community women Nash, Hatch and Worden to help the injured woman. Nash held the young lady's bleeding head in her lap as she washed it. Dr. Newport of Meriden arrived and dressed the head wound and a lacerated right limb. Again, Ann O'Rourke lost consciousness. Those attending her thought she had died, but twelve hours later, she awoke. By Sunday, she was out of danger.

The Perfectionist Community people took care of the Tracy children, taking one back with them for care and leaving two others with local families. With their parents and their ten-year-old brother dead, the injured Tracy

children were: Matthew (age nine), with his scalp nearly sheared off; Eloise, also known as Louise (age fourteen), with a serious injury to her arm; Mary (age fifteen), with a serious back injury; and seven-year-old Conrad Jr., with bruises. Days after the tornado, a newspaper reported that the Tracy girls were doing well—neither had broken bones, as had been thought. It went on to state that the Tracy boy "who was scalped, is getting along finely, and is around out of doors some," and "this boy and his sister Louisa are stopping in the house back of the Beach House on Academy Street, with some others, and are cared for by the Community folks, who have hired the building for their accommodation."

In addition to these charitable works, the community continued to pay the injured workers their wages during the days following the storm even though they were unable to report for work.

The Thomas and Alice Rynn house, which only a few hours earlier had provided a safe haven for Maggie Littlewood, now served as a makeshift hospital for the injured. Here, sixty-four-year-old Dr. Nehemiah Banks treated a multitude of injuries, including placing seventeen stitches on the scalp of nine-year-old Matthew Tracy. One of the most seriously injured patients was John Lee's fifty-seven-year-old wife, Mary, who lay on a mattress, moaning, as her twenty-year-old daughter cried and beseeched the doctor to help her mother. Mary died of internal injuries the following day at 3:00 p.m.

A few weeks after the tornado, on September 23, fifteen-year-old Mary Tracy, who had suffered a severe injury to her back, was again traumatized.

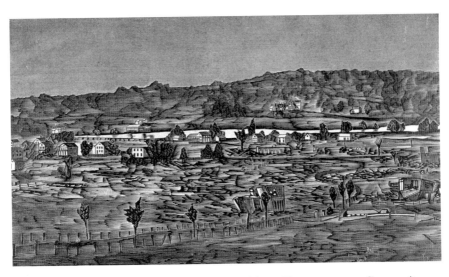

The Plains area after the tornado. In the distance, Mount Tom towers over Community Lake. *From* History of the Wallingford Disaster.

In her job at the Wallingford Perfectionist Community's factory, she injured the first finger on her right hand while working on a drop press. Dr. Henry Davis of Wallingford, who had worked hard to help the storm victims, was forced to amputate it. Mary's younger sister, Louise, who had incurred shoulder damage in the storm, also went to work in the community's factory.

Two years later, the United States Census shows the two elder Tracy sisters—along with two other Tracy children, Martha (age eleven) and Cornelius (age nine)—had found a home with Patrick and Ellen O'Neil and their four surviving children.

World-Renown Naturalist

Immediately after the tornado, Yale professor and naturalist William H. Brewer (1828–1910) spent a number of days in Wallingford investigating the storm. Brewer came with impressive credentials: he had co-founded both the Yale Forestry School and the Connecticut Agricultural Experiment Station and, in 1867, made recommendations about Alaska that led the United States to purchase it from Russia.

In Wallingford, Brewer took measurements on the path of devastation and observed the tornado's effects on the land and vegetation. He noted that the trees on the south edge of the whirling tornado's path were left pointing east, while the ones on the north edge faced in many directions. He also observed that the Wallingford tornado was marked by an absence of hail. Based upon his experience with tornadoes in the Great Plains, he concluded that the Wallingford one "had all the characteristics" of other tornadoes, but it was of "unusual strength."

"The Tail Seemed to Wind around the School-House"

John Kendrick called fourteen-year-old Elbridge Doolittle's account of the tornado "the most graphic description of the affair that has been given." At about 6:00 p.m., the boy was sitting at a window on the second floor of his house on Center Street watching the lightning storm to the north. He described it this way:

I saw the lightning flashing, and then heard a queer noise, and turned around and looked over to the lake, in which direction there was a rumbling and rolling noise. There was a crash, and then something shot up into the sky that looked like a cloud of smoke, and was so thick that I couldn't see through it. There was an awful roar, and it came along about five rods [eighty-two feet], *and then there were pieces of board and shingles and pieces of roof, I should think that were about so big* [measuring off a place about five feet square]. *Those I suppose came from Grasser's shop.*

The tornado, or whatever you call it, was about as wide as a house is long, and kept whirling round and round, being a good deal bigger at the top than at the bottom. It swept along awfully fast and tapered down at the bottom, like a balloon, with a long tail stringing under it, out of which a stream of water kept running, just like it would out of a tunnel. The tail kept swinging and whipping around like a snake. After it got well started the boards began to get thicker in it, and it struck something else, and things were lifted right up into the air and came scudding along until it reached the Catholic church, and that and the houses on the Plains went over just as tall grass blows down when a stiff wind blows across it. The buildings didn't weave at all, but went right over, some going up into the air, and it seemed to me as if the tail had twisted right around them and lifted them up. When it got opposite our house the thing was terribly black and thick, and was full of timbers, which kept turning end over end instead of spinning around like a top. It was full of limbs of trees, too, and they looked like big kites with the leaves at the top, and the limbs or trunks hanging down like the tail to a kite.

Every little while the stuff in the air would drop and another building would be picked up and thrown around. The tail kept dragging along the ground and all moved very rapidly, there being no stop until it reached the schoolhouse. Then I thought it stopped for a second or two, as if the schoolhouse was too big for it, but it went up into the air, and the tail seemed to wind around the school-house, I could see it so plainly. After it had wound around the schoolhouse, it started again with an awful roar, and instead of blowing over, it lifted the top of the schoolhouse right up into the air. Part of it dropped back again after it had got up a little ways, but the biggest part seemed to start on with the tornado. After it left the schoolhouse, I lost sight of it. I should think it took about three minutes for the whole thing to come from the lake to the schoolhouse.

Father Hugh Mallon, Holy Trinity's pastor, barely noticed the sound of wind in the distance as he ate his dinner. Only when he heard the clang of a

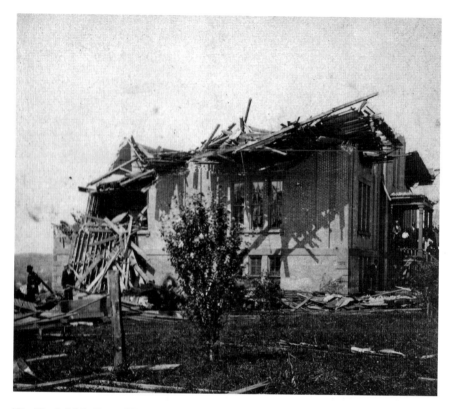

The North Main Street High School at the northwest corner of Main and Christian Street was four stories high before the tornado hit it. Taken from a stereoview published by D. S. Camp of Hartford. *From the author's collection.*

fire bell did he go to the back door of his house. Looking toward the Plains and his church, he spotted a small fire such as burning brush would make. A man coming through his yard brought the priest's attention to a roofless house in the distance. When Mallon saw it was tottering, he prepared to leave. Seconds later, someone in an upper window yelled out that he couldn't see Father Mallon's church.

With his way blocked by trees, the priest had to detour around side streets to reach the center of the devastation. People were frantically rushing around, screaming, shouting and crying. As an article a few days later in the official newspaper of the Diocese of Hartford stated, "nearly four streets full of its [Father Mallon's church's] members lay wounded, dying and dead in the ruins of their dwellings, which lay in piles of ruin, some of them crushed beneath the ruins, others blown into the street."

The article went on, "The Rev. Father went to work immediately, doing all the spiritual duties that could be done. Hat in hand he went from one to one as the rain poured in torrents upon him…lying dead and dying before him brethren who had been in perfect health a few hours before and who now were going and gone before their God."

Twenty minutes after the tornado left, the rain and wind stopped, the sky cleared and the darkness of night set in. Stars shone in the sky. Thirty-four people were either killed outright by the tornado or would die within weeks from their injuries. None were killed as a result of the lightning.

The monster twister lost power as it crossed East Farms Road. It was then about four miles from where it first formed. The rain that accompanied it stopped about twenty minutes later. The town hall bell was rung, and people began the search for the missing and dead among the house parts, iron kettles, furniture, kitchen stoves, bedding and clothing that were strewn over the Plains. Feathers from mattresses were distributed in an even layer over the ground.

Boy Rides Six Miles to Get Doctors

The day after the tornado, the *New York Times* reported the story of John Hoey, who rode six miles on horseback to get medical assistance. According to Kendrick, "Johnnie Hoey, a boy of 12 years, under orders from E.M. Judd, rode to Meriden for doctors; he rode on his horse and was back in less than an hour. This appeal brought to us many physicians from Meriden, some coming on the 8:37 p.m. express [train], which stopped, while others drove down." John knew well how to ride, as he helped his father manage a local livery stable. John Hoey passed away in 1913, at age forty-eight.

Another young hero, whose name is lost to history, played an important role. Only minutes after the tornado wrought its destruction, a train approached Wallingford from the north. The engineer was not aware that telegraph poles and other debris were covering the tracks. There was a good chance that it would have caused a serious derailment. However, a small boy ran up the tracks and waved his hat at the train. The engineer slowed down, and only a minor accident ensued, with the locomotive hitting some timber and losing its headlight.

On the train was twenty-year-old newspaper reporter Francis Atwater, who had passed through town two hours before on a northbound train.

After arriving at the Meriden station, he met a railroad conductor on a freight train to discuss a story. Then they left Meriden and headed south. As the train approached Wallingford, the engineer blew the whistle for "down brakes." Since freight cars did not have air brakes, it was necessary for railroad employees to climb to the top of each car and turn a wheel that brought down a pin.

The conductor leaned out the railroad car's door, and Atwater thought the man was going to jump off the train. He turned back to Atwater and told him to save himself. The reporter immediately grabbed an upright rod and braced for a crash.

Fortunately, the train was able to stop. Atwater looked out at debris strewn over the track. He saw the broken headlight and a telegraph wire that was stretched across the rails. All around the train were flattened buildings. The scene was especially shocking to Atwater because he had seen how it looked two hours earlier.

Atwater left the train and walked to the place on North Colony Street that was at the heart of the devastated area. In his 1922 memoir, he recalled that he saw "human bodies scattered about…They had been rolled over and over and were covered with mud and dirt. They looked as though they had been dead for days."

As he wandered through the debris of houses, barns and vegetation, another man joined him. Together, they searched for anyone who might still be alive. Just the day before, Atwater had visited this very neighborhood with local lawyer Seymour Hall, who owned many homes in the Plains area. As Hall collected the monthly rental payments, he introduced Atwater to his tenants, all of whom were Irish. In Atwater's words, Hall had "a jolly comment for all, which were quick wittedly returned." Now, as these people lay dead around him, Atwater recalled many of their names from the previous day.

Atwater and his companion found one woman among the tornado debris who begged them for a drink of water. As Atwater raised the woman's head to make her more comfortable, the other man looked around for a container. It took him a while, and the woman grew impatient. Sadly, as soon as it was offered to her, she died, and Atwater laid her back on the ground.

According to Atwater, "On the plains the houses were mostly one and one-half stories high, populated and rented by poor people. Many were returning from their day's work when the elements destroyed them." He goes on to remember that he saw relatively few injured people and surmised at the time that "the force [was] so great that no one in its path survived to tell the tale."

As Atwater came to the realization that a tornado must have been responsible for the devastation, he rushed to the train depot, which was about a half mile south of the center of the destruction. Placing telegrams to major newspapers in New York, Boston and other large cities, he inquired whether they wanted him to transmit a story. Six did.

Francis Atwater (1858–1935) was the first reporter to cover the tornado. He went on to great acclaim as a publisher, editor, author, railroad builder, organizer of corporations and the director of the Red Cross in Havana, Cuba. Although Atwater led a full and colorful life, he states in his memoirs that the Wallingford tornado "furnished the thrill of my life. Had our train been on time we would have been in the midst of the storm."

When the winds had subsided, a line of open cellars marked Colony Road. One house on High Street had been lifted off its foundation. There were no other remaining High Street houses; the rest had been demolished. One Wallingford octogenarian told this book's author, in 2014, that he still remembered an open cellar near High Street in the 1930s. He was told that it was the foundation of one of the houses destroyed in the tornado. Perhaps the last physical remnant of the tornado, it was later covered by an auto dealership.

The tornado had lasted less than two minutes, but the fatalities had occurred within a span of thirty seconds. That was more than one fatal injury per second. Few tornadoes in history have been so rapid and deadly.

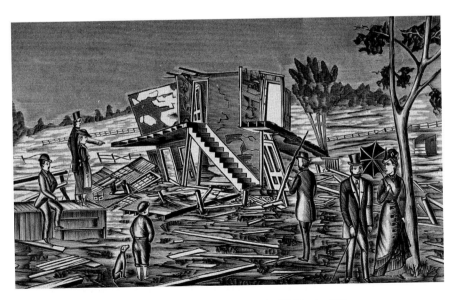

John Simmon's house on the Plains. *From* History of the Wallingford Disaster.

Of the twelve houses on Wallace Row, eleven were destroyed. These were occupied by Patrick O'Neil, Lawrence Downes, Mr. Matthews, John Paydrue, Patrick Coughlin, John Lynch, John Clyne, Patrick Clyne and J. Holbie. Another, owned by Mr. Luby, was currently unoccupied. The sole surviving Wallace Row home was occupied by Patrick Fleming. Fleming, a thirty-eight-year-old employee of the spoon shop, and his wife, Agnes, were both born in Ireland. At the time of the storm, they had four United States–born children, as well as one more on the way.

In the first house on Wallace Row, two of Patrick O'Neil's sons—John, age nine, and Patrick, age eight—were killed. Another son and a daughter saved themselves by crouching next to a cellar wall. The next house on the street also saw two fatal injuries. Mary Downs was killed instantaneously from head wounds and broken limbs. Her daughter by a previous marriage, Mary Healy, suffered similar wounds with probable internal injuries. Selectman Robert Wallace found her sitting in a chair. Grocery clerk George Hall volunteered to care for her at his house. When she arrived at the Halls' residence, George's wife, Anna, prepared a bed in the parlor for the injured young woman. Mary gave the impression she was not badly hurt, and Anna Hall left her. Minutes later, she returned to find Mary Healy had passed away.

THE SICKENING ODOR OF BURNING FLESH

Wallingford's doctors immediately rushed to the Plains area, not knowing what they might find. In some places, they had to drive over sidewalks with their buggies, as the roads were cluttered with boards, branches and every kind of debris. What they found shocked them. One man later said, "'Twas not a time for thoughts of property destroyed or houses ruined. We thought only of the dead, the dying, and the wounded. The sickening odor of burning flesh, and of slaughtered bodies dripping with blood and gore, spread like a cloud of vapor."

According to some sources, twenty-nine-year-old Wallingford doctor James McGaughey was the first on the scene to help the injured. A physician and surgeon, he had an office on Center Street. Another of the first Wallingford physicians to aid the victims was former Union army surgeon Benjamin Harrison. Later, he was chosen to serve as treasurer of the committee charged with distributing donations to people who had suffered losses. Physicians Mansfield, Newport, Otis, Tracy, Childs and

Dr. James D. McGaughey was possibly the first physician to reach the tornado victims. As medical examiner for the town of Wallingford, he signed almost all of the death certificates. *From the* History of New Haven County, Connecticut, *1892.*

Wilson also quickly arrived. Later, they were joined by forty-three-year-old Dr. Robert B. Goodyear of North Haven, sixty-two-year-old physician and surgeon Pliny A. Jewett of New Haven and physician Charles Lindsley, also from New Haven.

As the wounded were brought to them, the doctors busied themselves stopping the flow of blood from wounds, giving anesthetics and setting broken arms and legs. In a day when farming and industrial accidents were common, the doctors were no doubt experienced in treating serious wounds. More troubling were the cases of head trauma and internal injuries that resulted from people being crushed under falling houses or thrown through the air. An article published the day after the storm stated that almost all serious cases of injury appeared to be the result of victims being hit in the head by wooden building parts or tree limbs.

Thieves Stealing from the Wrecked Homes Less Than an Hour After the Tornado

At 9:00 p.m. on Friday, in the town hall, Selectman Robert Wallace swore in twenty-four special constables, charging them with the task of preventing looting. Apparently, thieves had begun stealing from the damaged and wrecked homes less than an hour after the tornado. Nine of the new constables were assigned to Main Street, where the most expensive homes sustained damage; the other fifteen were sent to the Plains area and patrolled the stretch from the train station to the decimated Irish neighborhood.

S.M. Scranton, a mechanic, was appointed chief, with Officer Goodrich of Meriden as his assistant. The constables on the Plains reported to forty-three-year-old, Ireland-born florist Patrick McKenna. The next morning, Edward Yale became chief of the constable force with George Hull as his assistant. On Wednesday, dozens more special constables were sworn in because many more visitors were expected due to the special rates the railroad had adopted for the day. All constables were identified by the word "police" on a satin ribbon that was pinned on their hatbands.

As the constables patrolled along the dirt streets, a dozen physicians were frantically laboring indoors to keep the injured alive. Dr. Goodyear was the first to treat nine-year-old Maggie Lynch. She had suffered a deep gash to her cheek, a broken upper right leg, a burned lower right leg, deep burns to her foot, back injuries and, perhaps most serious of all, internal injuries that could not be diagnosed well in 1878. Despite the heroic efforts of Dr. Goodyear and fellow physicians Dr. Jewett and Wallingford doctors Henry Davis and Nehemiah Banks, Maggie died twenty-two days after the tornado. Her death certificate states the cause of death to be "Tetanus, Injured by Tornado."

Almost all of the dead were Irish Catholics. One newspaper writer, almost a century later, while listing the names of the tornado victims, observed, "The toll reads like a Dublin phone book." The sole non-Catholic, Frederic Littlewood, was originally from London, England. The *Meriden Daily Republican*, on August 12, 1878, stated, "All were believers in the Roman Catholic faith except Mr. Littlewood, but as his wife belonged to that church, he was buried in the cemetery."

Many dead and injured people were found in the Plains lots between North Colony Road and North Main Street. Holy Trinity's pastor, Father Mallon, arranged for the old Colony Street schoolhouse to serve as a morgue, and twenty-one bodies were immediately transported there. The schoolhouse was a two-and-a-half-story brick building that measured fifty

feet long and thirty-eight feet wide. It sat in the middle of an empty lot on the east side of North Colony Road just north of the basement of the Holy Trinity Church, which was under construction. The site is now the location of Fazzino's Auto Parts. According to Kendrick:

> *E.H. Pratt* [a machinist], *after consultation with E.M. Judd* [one of the town's leading manufacturers], *started to open the brick schoolhouse on the Plains, but while on his way met Patrick Dignan, the principal of this school, who at once unlocked the building. This edifice was about sixty rods* [990 feet] *south of the sweep of the cyclone, and was a very suitable place for the removal of the dead. Into this building the killed were carried as rapidly as possible: wagons, drawn in some instances by hand, and containing sometimes two or three corpses, conveyed them to this house of the dead. None but the dead were admitted here.*
>
> *Frederic Littlewood's body was the first one brought in; and at 10 o'clock thirteen bodies were in this morgue, and the work of bringing in continued during the night. These were placed, some on boards, others in rude boxes;*

The site of the Colony Road school, which served as a temporary morgue for the tornado victims. The stump in the foreground was a young tree at the time of the tornado. *From the author's collection.*

and, being laid across the desks, were covered by blankets or cloths, only the face being left uncovered. As soon as ice could be obtained they were all ice-packed. It was a terrible sight, and brought tears to many eyes unused to such scenes. Men, who had spent years in the army, and seen death in many forms, and had felt his breath upon their own cheeks, say that they had never before witnessed so heart-rending a sight.

Lying before them were not the corpses of adult Civil War soldiers that many Wallingford men had seen a decade and a half earlier—rather, they were mostly the bodies of women and little children. As the dead were being moved to the small brick schoolhouse, pine boxes were placed on supports, and the bodies were covered with blood-stained sheets and blankets. E.M. Judd busied himself with straightening out the stiffening limbs and tying them with bandages and pieces of cloth. Curious people crowded around, eager to view the mangled and bloody bodies. Family members and friends slowly entered to identify the dead. The smell of blood was so strong that people congregating outside the schoolhouse could detect it.

A Wagon Stacked with Ice

A wagon stacked with ice was stationed at the school door. From it, men picked up ice and carried it inside. They packed it around the bodies, hoping that they would be preserved from the summer heat until the end of the funeral services. One newspaper correspondent described one woman's scalp as stripped off from just above the eyes to the base of the skull "as cleanly as though cut with a knife."

The day after the tornado, a reporter for the *Register* gave this firsthand account of the scene inside the schoolhouse:

The inside of the building presented a ghastly spectacle. On the tops of the benches were rows of pine boxes, covered with sheets which revealed the outlines of stark bodies. The floor was covered with water from the melting ice, and in it was mirrored the lights of the lamps and moving lanterns. The chill air of the room condensed the breath of the workers over the dead, dimming the light of the lamps and adding to the ghastliness of the scene. When all the pine boxes had been used, the bodies were stretched

on boards placed over the tops of the benches, and these were covered with blood-stained sheets.

A score or more of men were working over the mutilated dead, with sleeves rolled up and sweat streaming from their features. It was an experience which few of them had ever before undergone and none would wish again to encounter; yet all worked bravely and with quite as much coolness as could be expected. Between the rows of bodies, women with shawls over their heads passed, raising the wet cloths from the crushed features of the dead to catch a view of the face of some relative or friend, and at times when they would stand in groups, bending over some mutilated form and sobbing pitifully, the scene was heartrending.

Throughout the night, families and friends of the missing would enter the morgue and inquire about their loved ones. Both men and women openly wept.

The midnight train from New Haven brought the foreman of the Western Union telegraph line repair shop with a dozen of his men. They found that the poles that had been pulled out of the ground were still intact and repaired fourteen lines to restore communications by 1:00 a.m. Wallingford ticket agent Silas N. Edmonds worked until 3:30 a.m. on Saturday. He was probably aided by his wife, Serophina, who was the first Wallingford telegraph operator back in 1860.

Quickly, reporter Francis Atwater wrote his story and gave it to the operator. A couple hours later, other reporters arrived with their stories, but they had to wait until Atwater's work was completed. About midnight, the telegraph company sent in additional operators from New Haven. Atwater took the "Owl" train to Hartford and finished up his stories at about 4:00 a.m. in the *Hartford Courant's* editorial room.

WORRY OF HOSPITAL GANGRENE

In Meriden, the storm had caused $1,000 worth of damage to a newly constructed building at the Bradley and Hubbard Manufacturing Company, a business that specialized in the production of oil-burning lamps. At the same time, lightning struck the shop of Manning and Bowman, a manufacturer of housewares. Fortunately, a tornado did not form in Meriden, and no one was injured there. Meriden's physicians took the express train and arrived two hours after the tornado.

Of the 128 Wallingford residents injured, 35 of them were seriously hurt. A total of seventeen were sent to be treated by medical doctors, nurses and citizen volunteers in the two lower rooms of the Wallingford Town Hall, which was identified by a red flag flown over its dome. The makeshift hospital remained in operation for one week and did not have, at any time, more than fourteen people residing there. It was closed when Dr. Banks felt patients might contract hospital gangrene, a quickly spreading infection that was common in an age before antiseptics were widely used. Additionally, by closing the hospital, the town saved at least twenty dollars a day.

Included among the injured was Andrew Ennis, whose sixth birthday was in five days. In Kendrick's words, he had his "skull laid bare." His parents, two brothers and two sisters were not harmed. Little Andrew would live until 1957, dying at age eighty-five. His brother Charles, who was nine at the time of the tornado, lived to age ninety.

Ireland-born husband and wife, Barney and Bridget Cassidy, ages fifty-eight and forty-eight, respectively, were at first reported dead. Spoon shop worker Barney suffered internal injuries, and Bridget had a reported broken spine. Fortunately, both survived.

After the damage was assessed, it was determined that about forty homes and eighty barns and sheds were destroyed by the tornado, while another dozen homes were badly damaged. Over 150 people were left homeless, with damages estimated at $136,000.

An hour after the tornado, the seven o'clock train carried news north from Wallingford, arriving in Hartford at 7:45 p.m. From the devastation near the track in Wallingford, as well as hearsay, those first passengers out of town passed on word that between fifty and one hundred lives were lost. That evening in Hartford, over fifty people waited for the "steamboat" train from Springfield, Massachusetts, to take them south to Wallingford and to the scene of the disaster.

At 10:00 p.m., a reporter for the *Hartford Courant* newspaper arrived in Wallingford and noted the presence of numerous special police officers who had been sworn in and instructed to prevent looting. Within hours of the tornado, 24 special constables were hired at fifteen cents per hour. By the end of the disaster recovery, 138 constables had been hired. Some were armed only with canes or rolling pins. Most special constables refused to accept payment for their services.

By midnight on Friday, the ruins had been thoroughly searched for the injured and the dead. Since most of the adult men were still at work when the tornado attacked, nearly 80 percent of those killed were women and children. At least twelve were age ten or younger.

THE DAY AFTER

Early Saturday, local farmers used teams of oxen and axes and saws to clear Wallingford streets of toppled trees. Although all deaths had occurred in the Plains section, the four-mile-long area from Community Lake to Wallingford's border with the town of Durham was covered with uprooted and fallen trees and debris of every kind.

After leaving Wallingford, the storm continued on its eastward path, wrecking houses, barns and orchards in Durham and Killingworth. It blew down a small schoolhouse and damaged the Methodist church in Killingworth. Lesser damage was done to property in North Guilford and North Madison, although it blew down a dance hall in the latter town.

The storm then traveled high in the air, not setting down again until just before 8:00 p.m. It reached Watch Hill, a part of Westerly, Rhode Island, which is on a peninsula a few miles over the Connecticut–Rhode Island state line. At Watch Hill, the winds struck the Maine Steamship Company's steamer *Franconia*, which ran between Portland, Maine, and New York City.

Wallace Row looking east from North Colony Road. Only one house of the nine on this street survived total destruction, and a dozen people were fatally injured. *From the author's collection.*

The day after the twister, an 8:43 a.m. train brought both volunteer workers and sightseers to Wallingford. They came to see nature's destructiveness, to help out the victims or just to satisfy their morbid curiosity. Many visitors had read of the tornado in the New Haven and New York newspapers. The efficiency of the nineteenth-century press was impressive. Reporters had surveyed the damage, interviewed survivors and witnesses and filed their stories. Then, the newspapers set up the type, printed up thousands of copies and delivered them into the hands of hundreds of thousands of people. All this occurred within twelve hours.

In 1878, two railroad lines served Wallingford. The main one stopped at the downtown station and ran through the Plains; the other, the Air Line Rail Road, had a station in East Wallingford and ran from New Haven to Willimantic, Connecticut, a distance of about forty miles.

All visitors gravitated to the Plains, which was covered with open holes—the houses had been swept away, leaving only the cellars. Articles of clothing, boots, hats and bed sheets were left clinging to the branches of uprooted trees in a bizarre fashion. To veterans of the Civil War, the place looked like a battlefield.

Sole Remaining House

A popular attraction was the only house on Wallace Row to survive the tornado. The only damage it sustained was a hole in its roof made by a barrel of flour. The barrel had been stored inside in a hallway, and the winds had pulled it through the roof and deposited it on a hill beyond the house.

On Saturday, visitors might have seen the two most seriously injured survivors, Richard Taylor and Mary Condon, as they were taken to New Haven Hospital, or they might have observed patients at the temporary hospital at town hall being discharged to the care of their families and friends.

Arriving visitors were eager to hear the stories of local people, many of whom were injured by the storm. Thirty-three-year-old Mrs. Caten was carried away by the winds, dropped to the ground and covered by the ruins of one of the houses. Only her feet were left visible. It took thirty men to lift the timbers that held her down. Although badly wounded, she survived.

"But the Dog Isn't Dead Yit"

Near the Toohey house, a homeless man was wandering around talking to himself. Described by a reporter as over fifty years old, he was "hard-featured, blear-eyed, in dilapidated clothing, wearing a strap around his waist to secure his trousers." Walking with his hands in his pockets, he pulled a slouched hat down over his watery eyes.

Going up to the reporter, the man, who was obviously drunk, said:

> *The family is all gone, everyone, but the dog isn't dead yit. The dog isn't dead yit. The dog's time didn't come yit. It's pretty hard, and you can't tell why the dog was left and the others was kilt. Of course, I don't look as if I*

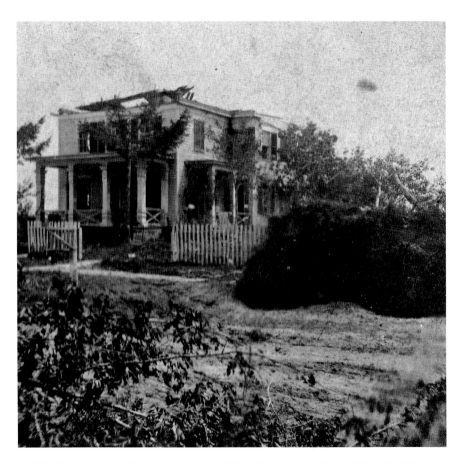

A Main Street house with tornado damage. Taken from a stereoview published by D.S. Camp of Hartford. *From the author's collection.*

knowd much, but I know more'n you think. The reason the dog wasn't tuk was the dog's turn didn't come. Got any fault to find with that? The dog's turn 'ill come soon enough.

With that, he went back to walking through the pieces of the house that littered the ground, periodically walking up to strangers and repeating his words about the dog. The man was Michael Toohey. Only hours before, the tornado had virtually decapitated his wife and left her body more mangled than any of the other victims. Their children were now motherless and homeless.

England-born George Joel, about forty-one years old, was rushing home as the tornado approached. Attempting to dodge roof shingles and branches, he was struck by a tree limb, thrown about forty feet and smashed up against a fence. He ended up with a broken arm and a damaged leg. George's wife, Elizabeth, was at home at the time. Their house lost most of its east side while its west side came through virtually unscathed. Elizabeth later stated that the storm seemed like a combination of earthquake and hurricane.

Scalp "Nearly Torn Off"

The wounded included forty-something Mary Condon, who had cuts and bruises. Mary's eleven-year-old daughter was seriously injured, but she apparently pulled through, since a couple years later, a thirteen-year-old daughter of Mary Condon was listed as working in the spoon shop.

On the morning after the tornado, Connecticut governor Richard Dudley Hubbard took the 11:20 a.m. train to Wallingford. The fifty-nine-year-old chief executive toured the ruins with General Stephen R. Smith of the Connecticut National Guard and Robert B. Wallace, Wallingford selectman and owner of R. Wallace and Sons, one of the largest businesses in town. Governor Hubbard, at one time an orphan himself, offered Wallace the use of tents from the state arsenal for the homeless families. He also handed borough warden Charles Yale $100 of his own money for their relief; however, he told his hosts that he did not believe it was necessary for the state militia to assist them. Hubbard stated that it was his belief that the local authorities appeared to be able to handle the problems existing in the aftermath of the storm.

There were many stories of people helping total strangers. Sixty-one-year-old farmer Hezekiah Hall, who owned a place three miles east of the disaster with his wife, Harriet, saw boards over ten feet long passing over

his house. One piece that he retrieved was later proven to be a door from one of the buildings on the Plains. Hall knew something was wrong and immediately set off for downtown Wallingford to help. As almost all roads were blocked with tree limbs and assorted debris, he traveled mostly through fields. He first aided the Jones family and then continued on to help others. Hall labored throughout the week, helping wherever he was needed.

"YOUR FOLKS AIN'T GOOD ENOUGH TO GO SUDDINT LIKE"

In *The Wallingford Disaster*, John Kendrick relates the conversation of a Protestant deacon from a neighboring town who visited Wallingford on Saturday to see the wreckage. The man saw "a poor, forlorn, helpless, bandaged victim sitting on the heap of kindling-wood which but the day before had been his home." The deacon said, "My poor fellow, how do you account for the fact that none but Catholics were killed yesterday?" Without hesitation, the quick-witted Irishman replied, "Sure and it's aisy enough accountin' for that; the Catholics are ready to die any minute, but your folks ain't good enough to go suddint like."

On the day after the tornado, borough warden Charles Yale was chosen by the authorities to telegraph the mayors of major Connecticut cities with this request: "A tornado has rendered a large number of our people destitute and suffering. Can anything be done in your churches tomorrow for their relief?" Everyone who responded promised to send aid.

In a time long before the introduction of modern methods of communications, news quickly traveled by telegraph. On the day following the tornado, the *Montreal Daily Witness* ran this piece:

> *New Haven, Conn, August 9—This afternoon a terrible tornado struck Wallingford, and demolished the old Catholic church on the plains, and leveled two houses in Wallace's Row. Several other houses were moved and injured. Going up the hill it demolished a $30,000 brick school-house, breaking off big elm trees as if they were pipe stems. Several persons have been killed and many wounded.*

Although the number of fatalities and the amount of damage reported was incorrect, it is still remarkable that, within less than a day after the disaster, news of it was reaching the homes of people in another country.

"Cows Were Flying as if They Had Wings"

For some people, the tornado experience was like something L. Frank Baum would describe two decades later in his book *The Wonderful Wizard of Oz*. As one of the injured Wallingford women stated, "I did not know whether to laugh or to cry; the pigs were whirling round in the air, cows were flying as if they had wings, and doors and furniture went by us and over us like lightning!" Another witness saw a goat that was tied to a long rope, lifted by the wind until it flew in the air like a kite. When the wind subsided, the goat came back down and, barely missing a beat, went back to munching on the grass.

Survivor Pat Cline was lifted up by the wind and ended up in a tree. After interviewing him, Kendrick wrote, "He looked back in no little wonder and terror, and saw flying toward him in the air a cow…but while he looked, she suddenly disappeared into a cellar, where she was found with broken horns." It was estimated at the time that the cow was blown a distance of several hundred feet.

Although a reporter wrote the day after the tornado that horses and cows had been killed "in considerable number" in the barns that were destroyed, apparently, the only horse killed was one belonging to William Hall. It was crushed when Hall's barn collapsed on it. This doesn't count the two horses that died Sunday night in New Haven of colic "superinduced by over-driving to Wallingford that day."

Days after the tornado, it was reported that not a single cow had been killed. Two 350-pound hogs were blown a quarter of a mile but were dropped unhurt.

Stripped of Clothing

Some residents lost their clothing to the wind. On Elm Street, George Stewart lost his coat and shirt to the strong winds as he clung to the limb of a tree. Another man lost all his clothing except for his shoes and his collar. A young woman, who had just returned home from work, was injured when thrown from her house and stripped of all her clothing, including her corset.

There are many stories of people who were amazingly spared death. While some people, such as Catherine Toohey and Mattie Mooney, were throw hundreds of feet by the tornado and killed, thirty-eight-year-old Ellen

O'Neil was tossed several hundred feet into John Munson's pasture, which was on the Main Street hill. Uninjured, she walked back to her house, only to discover that two of her children were dead. Maria Lenahan was thrown over six hundred feet, but she survived, too. One man was buried up to his neck in sand without serious injury.

As newspaper accounts and word of mouth spread news of the disaster throughout Connecticut and beyond, the curious came to Wallingford by the hundreds and then by the thousands. On Sunday, there were so many visitors in the small town that the special officers enforced the rule that carriages must "form a line, passing up one side and down the other." One resident, tired of being asked directions to the site of the tornado's formation, put up a sign near the train station that read "To the Lake."

Two days after the storm, someone counted 2,020 teams of horses passing down Main Street in less than an hour. It was said that from a hill three miles from the center of town, a person could make out the layout of the roads by the clouds of dust that were kicked up by the horses, buggies and wagons.

People took home souvenirs. There were reports of groups of people gathering around trees, cutting off pieces that showed tornado damage. But it wasn't only trees that were sought—broken pieces of lumber, the remains of furniture and pieces of the Catholic church's demolished organ were all fair game.

In the days before the invention of portable cameras, souvenir collecting was a common activity. One newspaper writer remarked that the amount of wood carried away as souvenirs could be counted in cords. Sometimes the items served a useful purpose; pieces of ironwork, which the winds ripped from the high school and deposited dozens of yards away, were broken up and sold for a total of $13.75, which was donated to Maggie Lynch. One of the most seriously injured, she lived until August 31.

Many people left donations after they viewed the destruction. By Sunday evening, the people of New Haven had donated about $1,600. This was quite a sum considering the purchasing power of the dollar at the time. Connecticut ads during August 1878 show that tooth extractions (by a licensed dentist) and men's white shirts were selling for $0.25 each.

"You Will Never Again, if You Live a Century, See the Like"

A reporter for the *Derby Transcript* newspaper (Derby is about twenty miles away from Wallingford) wrote, "If you can spare the money, go, all of you,

to the place and see it. You will never again, if you live a century, see the like." He went on to say: "Nothing equal to it was ever [seen] in any civilized portion of this country."

Wallingford's clergy—Catholic pastor Hugh Mallon, Methodist minister Joseph H. Beale, Episcopal priest Joseph Wildman and Congregationalist minister Herbert M. Tenney—were busy providing aid and comfort to the victims and their families.

The schoolhouse-turned-morgue was closed at 5:00 p.m. on Saturday and reopened at sunrise on Sunday for visitors. It closed again at 7:30 a.m. to allow the bodies to be prepared for the funerals. Benjamin Sutlief, who ran an undertaking and furniture business at the corner of Main and Academy Streets, finished the final preparations.

On Saturday, eight-year-old John Hayden and six-month-old John Daley were buried in Holy Trinity Cemetery. Spoon shop employee Thomas Ginty, who had been ill with tuberculosis and died during the first few minutes of the storm, was buried Sunday morning. His death certificate states that he died from "consumption" and relates he had it for one year. However, many people at the time believed that the shock of the tornado hastened his death. He has traditionally been counted as a victim of the storm.

Mary Lee and John Paden were also buried Sunday morning. Most of the other bodies were scheduled to be transported to Holy Trinity Cemetery on Sunday afternoon. Early Sunday morning, Father Mallon and constable supervisor Patrick McKenna pointed out the burial locations to men who would be digging the graves by hand.

At 11:00 a.m. on Sunday, as the bodies lay inside the Colony Street schoolhouse, a funeral mass was performed at a temporary altar set up on the building's porch. Between five hundred and six hundred people filled the front lawn. Father Leo, president of the Franciscan College at Allegany, New York (now St. Bonaventure University), officiated. After Mass, Father Leo asked everyone to pray for the salvation of the dead.

Sunday afternoon saw the death of eighteen-month-old Mary Ann Matthews. Her body was brought to New York the next day for burial. At 2:00 p.m. on Sunday, the entire Company K militia marched in uniform and under arms from the armory to Holy Trinity Cemetery. Thirty-five-year-old Captain William N. Mix, who had been first sergeant in the Fifth Connecticut Volunteer Infantry during the Civil War, commanded them. Many members of Company K were sworn in as special constables.

At 3:00 p.m., there were over 5,000 people on Christian Street in preparation for a Mass at the cemetery. At the schoolhouse, bodies were

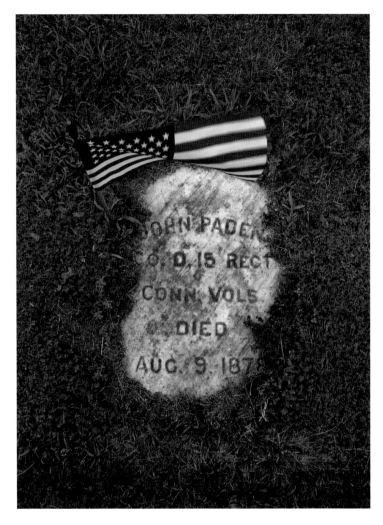

Civil War veteran John Paden's grave marker in Holy Trinity Cemetery.
From the author's collection.

prepared in coffins, which were sprinkled with holy water and placed on wagons. Factory owner E.M. Judd arranged for the procession to be lined up. The crowd at the schoolhouse had grown to about 1,500. Just before 4:00 p.m., it left for the short trip to the cemetery. The first wagon was decorated with a large floral cross, donated by the Baptist church. A wreath of white flowers sat upon each of the coffins.

Twenty-two Wagons Bearing Coffins with Twenty-four Bodies

The funeral procession was led by the constables, with Father Leo and Holy Trinity pastor Father Hugh Mallon accompanied by priests from New Haven. They were followed by twenty-two wagons bearing the coffins with twenty-four bodies; the fifty-six pallbearers, many of whom were Protestant members of the town; and other Wallingford residents and visitors who came for the burial.

According to newspaper reporter Francis Atwater, the service was "witnessed by probably the largest number of people Wallingford ever had at one time." The proceedings brought over ten thousand people and four thousand horse-drawn carriages.

At the cemetery, the crowd surged forward. Some people came so close to the empty graves that they caused dirt to spill into them. The force of constables pushed them back. Militia Company K also restrained spectators who pressed too close to the service. The homilist at the cemetery service for the tornado victims was twenty-seven-year-old Father Slocum (1851–1908). The Reverend Joseph Wildman, rector of Wallingford's Episcopal church, led the service for Fred Littlewood, the only non-Catholic buried that day.

Before Modern Pain Medications and Treatments

Of the living victims, the most critically injured was thirty-year-old Richard Taylor, who had suffered a broken back. For days, he was expected to die. He and thirteen-year-old Katie Condon were taken to the hospital in New Haven. It was reported that Richard Taylor was given morphine on a continuous basis starting Sunday after the tornado and had "wasted away until he is now but a mere skeleton" On Saturday, September 21, Taylor died in New Haven Hospital. Injuries to his spine had resulted in lower body paralysis. In his last days, he could consume only a little milk and beef broth. In an age before modern pain medications and treatments, he suffered greatly. Wallingford physician James McGaughey signed Taylor's death certificate. McGaughey, in his capacity as medical examiner, had also signed the death certificates of at least twenty-eight of the other victims.

Katie Condon would survive, but she remained in the hospital for over four months, finally being discharged on December 17.

On Monday, August 12, donations of food and clothing were brought to the town hall. A few days later, the collection point was moved to the basement of the Congregational church. At a relief committee meeting, Reverend Wildman reported that twenty-five families were in a destitute state.

The aftermath of terrible storms usually brought with it an array of conmen and thieves. Wallingford's tragedy was no different. On Monday, a man passing through the Plains area was soliciting money, ostensibly for the victims. He collected about $30 (equivalent to perhaps $3,000 in today's currency) and fled town before the police could question him. Officials advised residents and visitors that only people with red badges on their hats were authorized to collect donations.

Some thieves had ambitious objectives: men from New York tried to steal the bell from the tornado-damaged high school building. Members of the newly appointed special police drove them away. Although the tornado had blown the bell 150 feet away from the school, it was undamaged. When the school was rebuilt the following year, the bell was reinstalled.

TEN TIMES WALLINGFORD'S POPULATION ON THE STREETS

President Bishop of the New York, New Haven and Hartford Railroad cut the price of Wednesday's tickets to Wallingford in half and donated all profits to the tornado victims. This encouraged many people to come to town to view the damage. Based on the train capacities and the number of trains, one newspaper estimated that thirty thousand people arrived and departed by train from Wallingford on Wednesday. The aisle and platforms of the cars were filled to overflowing with men and boys. One estimate placed the total number of people on the streets of Wallingford on Wednesday, August 14, 1878, at fifty thousand, which was over ten times Wallingford's population. It was estimated that about fifty new booths and refreshment stands were set up in town on Wednesday to accommodate the visitors.

On the Wednesday after the tornado, Father Mallon began erecting a temporary roof over the new church's foundation. The special force of

constables was disbanded that night with only a few men retained to patrol the affected areas. Surprisingly, on Wednesday, with tens of thousands of strangers in town, only three people were arrested.

Reconstructing Buildings and Lives

Most factories in Wallingford remained closed until Monday, August 19, ten days after the tornado hit. In a day before wage and hour laws, when workers toiled away for ten- and twelve-hour days, this amount of time off was unprecedented.

A few days after the tornado, it was reported that fifteen thousand feet of tin roofing had been replaced on the Wallingford Perfectionist Community's factory on the south end of Community Lake. The community's other damaged factory, a one-story brick structure on Silk Street on the eastern edge of the lake, was a total loss. Their renter, forty-three-year-old, German-born George Grasser, also lost his barn, the chimney on his Christian Street house and a house on High Street. He and his Irish-born wife, Anna, had three sons and a daughter to support.

Newspapers began listing the names of all contributors and the amounts they gave. According to Kendrick's book, the money paid into the official relief fund up to September 29 was $14,529.00. This was broken down into 143 contributions that ranged from $0.50 to the $3,854.00 given by the railroad. Many of the amounts were the result of collections taken up by churches throughout the state, including Congregational, Baptist, Episcopal, Methodist and Catholic churches. The greatest contribution by individuals was $500 each from Wallingford residents Frances J. Curtis and Samuel Simpson.

Meriden artist Lewis Griswold sketched views of the devastation for the New York *Police Gazette. Harper's Weekly* featured full-page spreads of the ruins, which included drawings illustrating its impact. Newspapers throughout the country picked up the story of the freak tornado.

One of the people who responded immediately to the needs of the victims was thirty-two-year-old Julia Botsford, who served on the disaster's "Committee for Nurses," which arranged for medical care of all suffering victims. Mary Hallenbeck (age fifty-six), Emily Mansfield (age thirty-seven) and English-born druggist Thomas Pickford also served on the committee.

The relief committee doled out donated monies to the victims as it saw fit. However, there were disputes over who would receive the funds and how

much each person should get. Some uninsured homeowners were refusing to repair their damaged property because they claimed it was the town's responsibility to first give them the money for the repairs. There were also disagreements between the committee and a few people who demanded that unnecessary items be replaced. One complained that his replacement stove wasn't new, while another wanted a clock, which the committee considered "not strictly necessary to support life."

FUTURE OWNERS OF MACY'S DONATE

In the days immediately after the tornado, victims needed food (especially canned fruit), clothing and bedding. Donations came in from both within and outside Connecticut. L. Strauss and Sons, a Jewish American crockery dealer in New York City, sent a cask of crockery and glassware along with a note that stated it wanted to give the "the unfortunate sufferers of your enterprising town…something more tangible than empty sympathy." In 1895, the owners, brothers Nathan and Isidor Strauss, went on to become famous as the owners of the R.H. Macy and Company department store. Later, Nathan continued the family's devotion to charity by donating millions to children's health organizations.

Eleven days after the disaster, an article appeared in the *Hartford Courant* newspaper demanding that the relief committee reveal in detail its plans on the distribution of funds. It claimed that "many who are willing to aid the sufferers are withholding their charity for the lack of this information." It went on to argue that some of the more affluent homeowners on the hill were more deserving of the monies than some of the Plains people who would use them to replace "buildings which were heavily mortgaged and cheap structures." The anonymous writer did not comment on what monies, if any, they would recommend paying the property-poor Plains residents who had lost members of their families.

As the squabbles over relief payments continued, out-of-towners flowed into town to view the scenes of destruction and speak with the eyewitnesses. Many people dropped off donations before they left.

A young man of enterprise, Daniel O'Reilly, the first person to feel the effects of the tornado, opened a lemonade stand on Colony Street, just south of the scene of the worst devastation. Many visitors to Wallingford had read of the story of O'Reilly's boat on Community Lake and were

pleased to meet him and buy his cold drinks and peanuts. It probably appeared at the time that O'Reilly would embark on a business career; however, fate had something different in store for the young Irishman.

PAPER BLOWN SEVENTY MILES

Approximately sixty-five miles directly east of Wallingford on the morning after the tornado, industrialist Rowland G. Hazard II of Peacedale, Rhode Island (about ten miles west of Newport), found a torn and damp paper receipt while on a walk. It read:

> *Wallingford, Nov. 24 '76.*
> *Received from Mr. P. Cline ten dollars 00–100 in full of Account.*
> *James McClarnan.*

Hazard later spotted an article in the *Providence Journal* newspaper entitled "A Tornado in Wallingford, Conn." and noticed that a John Cline was listed as one of the injured. The Providence paper later published Hazard's story and the text of the receipt.

In Wallingford, Judge Othniel I. Martin saw the article about the finding of the receipt and replied that he knew both Cline and McClarnan and that Cline's house was one of those totally destroyed by the storm and that its contents had been scattered by the winds. The judge added that there was originally fifty dollars in the drawer with the receipt, and the Cline family could use the money if it was found.

Hazard did not find any cash, but the good folks of Rhode Island took up a collection. Fifty-five dollars was donated, and a check for that amount was sent to Judge Martin for presentation to the Cline family. John Kendrick, in his book, added his own "moral" to the story: "Keep your receipts; but if you don't keep them, send them to Rhode Island." At the time, one wag wrote in a local paper that this money was presented to Cline and that it would enable him "more peacefully to re-Cline."

The day after the tornado, photographers began descending on Wallingford. They wanted to capture evidence of the property damage before extensive cleanup and rebuilding began. At least six photographers took photographs using the new stereoscopic view technology, which was a popular form of entertainment that gave the viewer a three-dimensional

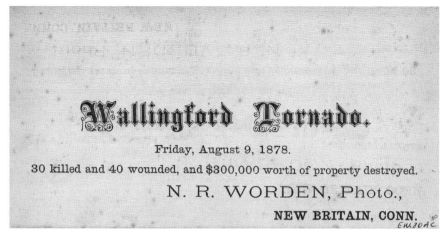

Wallingford Tornado.

Friday, August 9, 1878.

30 killed and 40 wounded, and $300,000 worth of property destroyed.

N. R. WORDEN, Photo.,

NEW BRITAIN, CONN.

The reverse side of N.R. Worden's stereoview of John Simmons's house. *From the author's collection.*

image of a photograph through the use of a handheld wooden device and duplicate pictures. It was a direct ancestor of the mid-twentieth-century toy the View-Master, which allowed children to view three-dimensional still images of travel attractions and television programs.

A week after the tornado, one Hartford business, J.H. Woodruff and Company, ran newspaper ads offering for sale "A Splended Assortment of 31 Stereoscopic views of the devastation caused by the tornado at Wallingford, Aug. 9th 1878." They offered to copy, enlarge or finish them in ink and water colors.

On the Thursday after the tornado, Worchester, Massachusetts' *Massachusetts Spy* newspaper ran a paragraph that included the statement that Wallingford, Connecticut, "was visited by a terrible tornado, which laid prostate to the ground everything in its course. It took a southwesterly direction, and swept into ruins three and twenty buildings." Overlooking the fact that it got the wind direction wrong, the piece is interesting because of one fact: seventy-five years later, Worchester would suffer from the effects of its own powerful tornado. In fact, it would be the only twister in the history of New England that would kill more people than the Wallingford tornado.

John Kendrick's official account of the tornado was published in September 1878 as a limited edition seventy-six-page book. On anniversaries of the disaster or after the occurrence of other northeastern tornadoes, local newspapers would include feature articles, often with interviews with people who had witnessed the Wallingford tornado or viewed the devastation. Many would feature extensive quotations from Kendrick's book.

THE LAST EYEWITNESSES

One of the last eyewitness stories was told by Cheshire, Connecticut's Frederick Kilbourne. A full eighty years after the storm, he related his memories for a reporter for the *Meriden Record* newspaper. As a six-year-old boy living on Wallingford's North Cherry Street, Kilbourne saw the tornado forming in the distance. He ran into the street to greet his father, who just made it home from work in time to find shelter. Fortunately, their house was protected by a grove of large oak trees and by the fact that it wasn't in the center of the tornado's path. In the 1958 article, Kilbourne remembered how his father had served as a rescue worker the night of the storm, and he described a house he had seen that had been sliced in two and ended up with its second story resting on its foundation.

Kilbourne's father was one of the many men and women who stepped forward to assist the needy. The expenses incurred to treat the wounded, bury the dead, clean up the vast amount of debris and rebuild the neighborhood were massive. Donations helped greatly. Countless people gave their time, energy and money. Nonetheless, there were some stories of people who took advantage of the tragedy.

One Middletown undertaker presented Wallingford with a hefty bill for expenses incurred in burying the tornado's victims. It included fifty-four dollars for eighteen wagons to be used as hearses. Since these wagons were provided by and driven by Wallingford residents, Wallingford's selectmen refused to pay the bill.

In the aftermath of the tornado, the town took over management of the many tasks associated with providing aid to victims and rebuilding the neighborhood. This included controlling the thousands of curious visitors who poured into town, the cleanup of the wreckage and the solicitation and distribution of monetary and non-monetary donations.

In the Main Street area, homeowners quickly moved to repair their property, replacing roofs on houses and barns. The only property they couldn't replace on the hill were the majestic elms that had graced Main and Elm Streets and given the latter its name.

Less than a month after the tornado, a severe thunder and lightning storm struck Wallingford, raising horrific memories of the past storm. The people in the Plains who had lost family members and friends were especially fearful that another tornado was coming. In fact, two young girls there were so frightened that they fainted repeatedly, and people attending them feared that they would literally die from fright.

Late in 1878, Sergeants William A. Glassford and I.A. Reed of the United States Signal Corps described and analyzed the Wallingford tornado in the corps' annual report to the secretary of war.

THE SADDEST SURVIVOR

Perhaps the saddest survivor story to come out of the Wallingford tornado was that of Edward Mooney. While he was away at work, the tornado fatally injured six members of his family. Mooney narrowly escaped death again about three years later. One night in the winter of 1881, he fell into an old, unused well in the Mount Carmel section of the neighboring town of Hamden. For an hour, he stood in four feet of frigid water at the bottom of the forty-foot-deep well, shouting for help. No one came to his aid. Women nearby thought his cries came from a ghost and were too fearful to investigate. Several men approached but couldn't determine where Mooney's voice was

Father Hugh Mallon's tomb at the entrance to Holy Trinity Church, North Colony Road, Wallingford. *From the author's collection.*

coming from. Fortunately, when they finally rescued him, Mooney suffered only bruises.

By the end of 1878, repairs had been made to most structures, and new construction had begun in the Plains area. The Irish survivors named their tornado-devastated area New City. The high school at the top of Christian Street was reconstructed at a cost of $8,500.

After his confrontation with the tornado on the waters of Community Lake, Daniel O'Reilly had been written up in newspapers near and far. Everyone in Wallingford knew him by sight. Everyone wanted to shake his hand and hear him tell his tale for the umpteenth time.

So, when Wallingford needed a man to police the saloons of town all night long, it chose O'Reilly. According to Clarence Hale, in his book *Tales of Old Wallingford*, although O'Reilly was only five-foot-five, he was 175 pounds of "fighting Irishman, all muscle, bone, and sinew, solid as a rock and strong as a bull."

Four years after his encounter with the tornado on a rowboat, O'Reilly was appointed to Wallingford's police force. Actually, he *was* the Borough of Wallingford's police force, as he was the only law enforcement officer in the downtown area for almost two decades. When, early in O'Reilly's career, the warden of Wallingford stated that technically he was chief of police, O'Reilly retorted, "Of course you are ex officio chief, but I'm doing the work and therefore the chief as well as the whole department." Finally, the court of burgesses voted to name O'Reilly chief-in-fact.

At Chief O'Reilly's death, the *Meriden Daily Journal* newspaper stated, "There have been few men in the public service of vital importance to the community...who discharged the duties of a law enforcement officer under such adverse conditions as did Daniel O'Reilly."

WALLINGFORD'S TORNADO ALLEY TODAY

After the tornado, the affluent homeowners in the Main Street area quickly began to have their roofs, chimneys and barns repaired. The solid construction of these houses, as well as the fact that the tornado was several feet off the ground at the time it struck them, meant that all damage was repairable. Although the tornado was a fearful memory for many of these residents, no one in the Main Street area had been killed in the storm.

The section of North Colony Road just north of Holy Trinity Cemetery. Many of the victims were killed here. *From the author's collection.*

With the monies donated by churches, community groups and individuals throughout Connecticut, the poor people of the Plains also began to rebuild. Father Mallon crossed the state soliciting donations so lumber, glass and hardware could be purchased for the construction of new houses and barns.

Today, the streets where the tornado chalked up its death toll—High Street, Wallace Row, Christian Street and the portion of North Colony Road that intersects these streets—are filled to capacity with small and medium-sized homes. Some, like the small George Grasser house and a handful of others, are survivors of the tornado. Most of today's smaller houses were replacements for the homes that were lost to the tornado; the larger houses on these streets were added later in the 1800s or early 1900s.

The original wooden Holy Trinity Church had a small, attached cemetery. After the remains of the church building were cleared and the monuments reset, the entire flat lot was set aside to serve solely as cemetery grounds. An adjacent, also flat, parcel of land to the north was added to the cemetery.

Farther east, up the gradually sloping hill toward Main Street, scores of middle-class homes sit where, in 1878, there were only orchards. At the top

of the ridge, on Main Street, most of the large homes that survived the storm still remain. Interspersed among them are intricately detailed Victorian mansions that sprouted up in the few decades after the tornado. After the tornado's damage was assessed, the top floors of the high school building at the northwest corner of Main and Christian Streets were redesigned and the school rebuilt. One story shorter than the original, it was opened in 1879 and was used until 1950. The Moses V. Beach Elementary School now occupies the site.

Over the years, stories have persisted that the current school building is haunted. Passersby are said to have heard music or seen lights in the school after hours when no one is in the building. It's said that when the authorities enter the building, the music and lights immediately switch off. Some say that during the night of the tornado, a prom was scheduled to be held in the high school. However, one fact is indisputable: the original school was unoccupied when the twister destroyed most of it, and it killed no one in or near the building.

The full-sized Community Lake, created by the Wallingford Perfectionist Community, finally came to an end on January 25, 1979. That month, three major rainstorms hit Connecticut and damaged half a dozen dams in Clinton, Lebanon, East Haddam and Wallingford. The biggest casualty was the Community Lake dam. When it broke, it released almost all the water from the ninety-four-acre lake. It was never fully dammed up again. Long before, the manufacturers who had benefited from the dam's waterpower had either left town or converted to other sources of energy.

Today, three relatively small bodies of water are all that remain of Community Lake. A municipal park, a walking trail and the Wallingford Senior Center surround them. While there have been proposals to dam up the Quinnipiac River again, just as the Perfectionist Community had done, many residents consider the multimillion-dollar price tag for dredging and damming prohibitive. Besides, say opponents, the present property is now back to its natural state.

The Wallingford Perfectionist Community disbanded within two years of the tornado. Today, only its largest factory, which sat next to the Quinnipiac River dam, remains. The original brick walls can be seen above the ceiling panels of the large, sprawling white building that serves as the world headquarters of the multibillion-dollar Amphenol Corporation, a major producer of cables, interconnect systems and electronic and fiber optic connectors. However, there is no relationship between Amphenol and the Perfectionists. The latter sold the property in the 1880s. The only similarity

between the two enterprises is that each achieved notable financial success on a worldwide scale.

Today, the average citizen of Wallingford has no idea that Community Lake was once much larger, that it was named after a religious cult or that the deadliest tornado in Connecticut history developed on it and wiped out an entire neighborhood of the town.

No monuments to the storm's victims have been constructed; no plaques have been erected. The only physical evidence of the tornado that the author is aware of is one family's obelisk in Holy Trinity Cemetery and a framed page of *Harper's Weekly* drawings in the public library.

EVALUATION OF THE WALLINGFORD TORNADO

A year after the Wallingford tornado, United States Signal Corps employee John Finley was assigned to study tornadoes throughout the United States. To his dismay, in the middle of his research, the Signal Corps banned the word "tornado" from its official weather forecasts because it claimed its use might cause panic among the general population. The ban remained in effect for over sixty years, only to be rescinded in the early 1950s.

Today, tornado intensity is most commonly rated according to the Fujita scale (F-Scale). Named for its creator, Japanese-born American Tetsuya Theodore "Ted" Fujita, it is used to classify tornado intensity. It ranges from a F0 for light damage to F5 for "incredible damage." Experts have estimated the Wallingford tornado to be an F4. F4 is reserved for wind speeds of 207 through 260 miles per hour and "devastating damage. Well-constructed houses leveled; structures with weak foundations blown away some distance; cars thrown and large missiles generated."

Before the Wallingford tornado, records showed only ten other tornado outbreaks in the United States had caused fatalities. Of these, only four caused more deaths than Wallingford's. They all hit the central or southern portions of the United States.

The Wallingford twister is also known as a rare waterspout. The Storm Prediction Center of the National Oceanic and Atmospheric Administration (NOAA) says, "Although waterspouts are always tornadoes by definition, they don't officially count in tornado records unless they hit land. They are smaller and weaker than the most intense Great Plains tornadoes, but still

can be quite dangerous." According to this description, the Wallingford tornado was apparently one of the exceptionally strong waterspouts.

Well into the twentieth century, throughout the United States, the word "Wallingford" was synonymous with tornado. For seventy-five years after it devastated Wallingford, the 1878 tornado stayed in the record books as the most lethal tornado in New England history. Then, on June 9, 1953, Worcester, Massachusetts, was hit by another super tornado. Passing from Petersham to Southboro, the Worcester tornado was on the ground for eighty-four minutes. Four thousand buildings were destroyed, $53 million of damage incurred, 1,300 people injured and 94 fatally wounded. After it severely damaged Assumption College in Worcester, it left 10,000 people homeless. Twenty-four hours before, the same storm system had killed 135 people in Michigan and Ohio. As of 2014, no other New England tornado has come close to matching the carnage of the 1878 and 1953 storms.

With a small number of local residents still alive to tell of the 1878 twister, the Worchester storm was the talk of Wallingford. The local Junior Chamber of Commerce arranged a caravan of fifteen vehicles to bring food and clothing to the Worchester tornado survivors. Town ham radio operators hooked up connections with Worchester to aid relief efforts.

Today, the Wallingford tornado ranks as the deadliest Connecticut tornado of all time and the second deadliest New England tornado. Not including the Worchester twister, the Massachusetts total of tornado-induced fatalities in its near four-hundred-year-long history is twenty-eight. New Hampshire has had thirteen killed and Maine only two. Both Vermont and Rhode Island are fortunate in never having had a tornado fatality.

Almost all of the Wallingford tornado victims were buried in Holy Trinity Cemetery. Sadly, all but three or four lie in unmarked graves. Over the years, the inexpensive markers have been disintegrated or removed. Today, the only reference to the deadly storm is the inscription "Killed by the Tornado" on the tall obelisk above the remains of victim Ellen Lynch.

The final story of the Wallingford, Connecticut tornado takes us back to its first victim, Police Chief Daniel O'Reilly. In 1926, he retired after serving for forty years on Wallingford's police force, including thirty years as chief or de facto chief. O'Reilly settled down with a comfortable pension to live the remainder of his days in the town he had loved and protected for so long. Many times, he must have thought back to that terrifying day in 1878, especially whenever he drove past Community Lake or reminisced with his friends over a game of setback at the Wallingford Club.

Daniel O'Reilly's obelisk in Holy Trinity Cemetery, North Colony Road, Wallingford. *From the author's collection.*

In 1938, at the age of eighty-three, the old chief passed away. At his death, the *Meriden Record* quoted one citizen of Wallingford who said of O'Reilly, "He has made his own monument by his many good deeds." It was the year of the Great Hurricane of 1938. Like Mark Twain, who was born when Hailey's Comet was in the skies and died when it returned, O'Reilly came into prominence as a victim of the worst tornado ever to hit New England and, sixty years later, left this life in the year of the worst hurricane to ever to hit New England.

Today, a tall brownstone obelisk sits above the grave of Daniel O'Reilly in Most Holy Trinity Cemetery on North Colony Road. It's only a few yards away from the location of the old wooden church that was destroyed by the storm, and it's surrounded by the graves of about thirty of the victims of the deadliest tornado in Connecticut history.

3
THE WINDSOR—WINDSOR LOCKS TORNADO OF 1979

Settled in 1633 on the western side of the Connecticut River, Windsor was the first English town in the state of Connecticut. Over time, its location just north of Hartford led to its development into a residential suburb. By 1979, it had a population of about twenty-five thousand.

Windsor's northern neighbor, the town of Windsor Locks, had about twelve thousand residents in 1979. Its claim to fame was Bradley International Airport, New England's second-busiest airport. Only Boston's Logan International Airport could boast of more traffic.

On Wednesday afternoon, October 3, 1979, weather forecasters predicted thunderstorms—nothing more. Unfortunately, residents of Windsor and Windsor Locks were to experience a terrible natural phenomenon, the likes of which Connecticut hadn't seen in a century.

At about 2:00 p.m., the sky turned dark, and thunder and lightning were expected. Susan Brown, a high school student, was heading home. While on the bus, she noted that the "sky was looking kind of weird." It had a greenish color—a color she "hadn't seen before."

The National Weather Service at Bradley International Airport, only a few miles to the north, issued severe weather warnings. No mention was made of the possibility of a tornado. Tornadoes were an unlikely possibility in Connecticut. In the three centuries of recorded Connecticut history prior to 1979, only four sightings of tornado funnels had occurred in October.

At about five minutes before three o'clock, a tornado funnel formed just south of the Farmington River in Windsor (some people said it developed

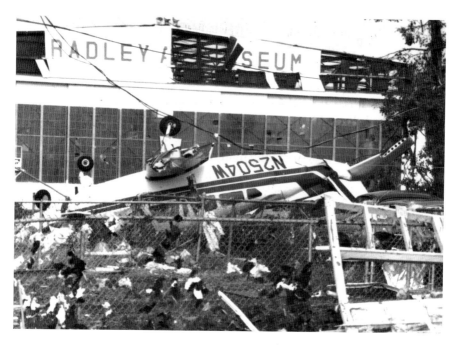

The former headquarters of the Bradley Air Museum. *From Chip Carey, Windsor Locks/ Windsor Locks Historical Society.*

in the river). Passing north up Route 75, it smashed into the Poquonock Elementary School, seriously damaging the roof and blowing in doors and windows. Fortunately, classes had ended for the day, and most students had left the school before the tornado hit.

On the day of the tornado, Susan's father, Stanton Brown, was at the south side of the Farmington River supervising workers who were packing tobacco. As the sky darkened and the winds picked up, he moved the men out of harm's way minutes before the tornado struck. Nearby, sheds collapsed on the crates. As Stanton made his way on foot along Tunxis Street, he saw twisted tree trunks. Without hesitation, he exclaimed to his companions, "This is a tornado!"

Along with his wife, Jane, Stanton Brown was the owner of Brown's Harvest, which carried on a family tradition of producing cigar tobacco, as well as growing potatoes, strawberries, blueberries and other crops. Their home was north of the Farmington River not far from St. Joseph's Cemetery. When Stanton reached the bridge by the river, he found it closed by the authorities. They needed to make sure the tornado's winds hadn't made it unsafe.

The town's senior citizen bus driver called in to report that high winds had overturned his bus. When town officials arrived on the scene, they were astonished to find cars and trucks flipped over, exposed concrete foundations, buildings in pieces and debris everywhere.

The quarter-mile- to mile-wide tornado ripped through the middle-class neighborhoods branching off both sides of Route 75, flattening or severely damaging scores of homes—ranches, split levels and Colonials. Fortunately, many people were still at work, and many children weren't home from school.

The home of Jane and Stanton Brown was in the storm's path. Two of the Brown children, both high school students, were at home. Daughter Kathy had come home from school on the city bus after a half day of school; her younger brother was home from Suffield High School. Daughter Susan was in school south of the Farmington River, having stayed late for band rehearsal. The two children at home sought shelter in their basement with their dog, Ginger.

It Looks Like a Dead Grasshopper

Their mother, Jane Brown, was grocery shopping in Windsor Locks. While in the store, she heard a loud clap of thunder and rushed to her car. As she drove toward home, she turned on the radio but couldn't locate any storm warnings. She passed the Ramada Inn, which was known for the airplane that it displayed outside to catch passing motorists' attention. When Jane looked at the hotel, she thought, "Something's wrong here. Something looks different. The place looks vacant." Then she realized why—the plane was gone; it was lying upside down in the middle of the road! It looked to her like a "dead grasshopper."

As Jane continued down the road, everything appeared demolished, like a bomb had gone off. She began thinking that "all these people have died." Everything was "very, very quiet." As she passed a wrecked hardware store, she wondered if the owner had been able to get out in time. "Maybe a fire caused this," she thought, but she didn't see signs of fire anywhere—nothing looked burnt.

She tried to cross over downed wires. Only later did she consider the possibility that some might have been live. Debris was everywhere. She abandoned her car at the edge of the St. Joseph's Catholic Cemetery and ran across the grass toward home, her feet sinking into the water-saturated

soil. Around her, she saw countless grave markers that had been blown over. She didn't know it at the time, but the tornado had been at its strongest when it passed through the cemetery. Meteorologist Ted Fujita, perhaps the world's foremost expert on tornadoes, later estimated that its winds at that point were between 200 and 260 miles per hour.

Jane's biggest concern was her children. Were they all right? Was their house in one piece? She was relieved when she spotted the rooftop. It was intact! The back porch was damaged, and broken glass was everywhere inside, but the kids were OK.

"This Is How I'm Going to Go"

During the storm, the children's dog had run up the cellar stairs and vanished into the house. Kathy Brown followed, trying to retrieve her. As she reached the top of the basement steps, the front door blew in, and the double-thermal living room picture window shattered inward. Kathy was caught on the top steps. The wind from the front door and picture window was so powerful it held the inward-swinging door against her, pressing her against the cellar stairway wall. Her thought was, "This is how I'm going to go."

All of a sudden, everything just stopped. All was quiet. As Kathy pushed the door open, she expected to see that the entire house was gone. Instead, she found the house intact, but with broken glass everywhere. She could see through the crack in the nearby door—the sun was out. Perhaps most chilling of all, she found chards of glass from the shattered picture window embedded in the wall a few feet away. Just a short while before, she had stood at that spot.

As Kathy went outside, she was astonished to see the large maple and oak trees bent over toward the north. She and her brother had survived a killer storm. It was a day they would never forget, and neither would their dog. For the rest of Ginger's life, she was afraid of storms, and at the first sign of loud wind or clap of thunder, she was "desperate to get down in the cellar."

After Jane reached home, she was able to contact her other daughter, Susan, who was stranded south of the bridge. The power was out, but the telephones still worked. She arranged for the girl to spend the night with her grandmother. She ended up staying there three days, as the bridge was closed until it could be checked for structural soundness.

Although only two miles south of her own home, her grandmother's neighborhood experienced nothing, not even rain. However, Susan

remembers that after the tornado passed, she could see up Route 75 and "everything looked white"—it was all ground and white sky since most of the trees and man-made structures had been leveled.

Just a couple blocks from the Browns, homeowners in the Pioneer Drive area, on the other side of Poquonock Avenue, suffered the worst damage of the storm. Nearly 90 percent of the houses on Pioneer Drive, Meakin Drive and Settler Circle were destroyed. Other streets affected north of the Farmington River included: Hollow Brook Road, Oxcart Drive, River Street, Coach Circle, High Street, Rainbow Road and Niles Road. South of the river, Darwyn Drive, Stacy Drive and Tunxis Street experienced damage.

Upon receiving a report that Automatic Lube on Tunxis Street had been blown down, the Windsor Police Department instructed all officers, both on- and off-duty personnel, to report to the area. They immediately converged to assist the wounded and to control traffic. They established first-aid stations at the Poquonock Fire House and Dale Drug and sent alerts to fire departments, rescue squads, emergency medical technicians, Civil Defense volunteers, ambulance companies, utility companies, highway crews and state and town officials. Doctors and nurses also converged upon the stricken area. State and Windsor police went door to door throughout the hard-hit neighborhoods locating and identifying the injured.

"Who Cares About All This Stuff Lying Around?"

One of the residents of Settler Circle, forty-two-year-old Carol Dombrowski, was reported missing. Police officers with bloodhounds, neighborhood volunteers, firefighters and construction workers with heavy-duty equipment to remove rubble spent many hours searching.

Finally, on the afternoon of the fourth, Dombrowski's body was located under debris. She had been thrown out of her home and carried away about four hundred feet. The *Windsor Journal* quoted one woman on adjacent Pioneer Drive as saying, "Who cares about all this stuff lying around, we can build it back up again, but that woman's life can never be replaced."

As the tornado swept north, it destroyed both the Hartford National Bank building and Rice Hardware, which were located by the corner of Poquonock Avenue and High Street. Mascherino's Garden Center's roof collapsed.

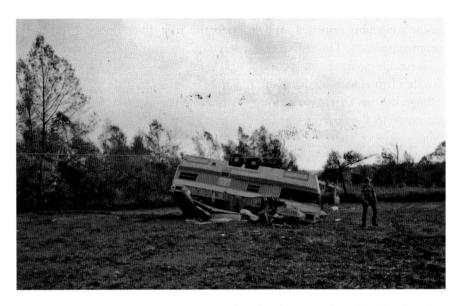

The upside-down Brown family trailer in Windsor after the 1979 twister. *From Jane Brown's collection.*

The second person to die the day of the storm was twenty-four-year-old Manchester resident William Kowalsky, who was working on the roof of the Hartford National Bank building. He saw the tornado coming, ran to the shelter of a truck and incurred fatal head injuries when a piece of lumber crashed through the windshield and struck him. A heavy equipment operator at Difford Construction Company of Glastonbury, Kowalsky died at Hartford Hospital.

After Jane Brown saw that her family was safe, she went outside to survey the damage in the neighborhood. She recalled, "One house would be perfectly fine, but the next house would be gone." The Browns lost five tobacco sheds and a twenty-four-foot camper, which was tossed a long distance, landed upside down and ended up looking like a pretzel. One house near the Browns' lost half its side. Through the opening, tiny figurines could be seen on a shelf, unscathed.

Jane Brown saw half of a tree—the other half had vanished. It lived for another year. On Poquonock Avenue, a 120-foot European white weeping birch was uprooted. It was thought to be the largest and oldest specimen of its kind in New England.

At the Hollow Brook Road development, Jane saw one house that was especially bizarre. The twister had lifted its roof into the air, sucked the

house's curtains outward and dropped the roof back down to nearly its original position. The curtains were left flapping from the sides of the house.

Dave Cermola of Poquonock Avenue in Windsor tells the story of his family's brush with the tornado. It started with his mother, Barbara, seeing a huge branch fly past her picture window. That was followed by a frantic scramble to the basement stairs by Dave's sister and a friend. The friend, who was over six feet tall, wasn't fast enough for the five-foot, two-inch Barbara, who pushed him and her daughter down the stairs. Barbara then dived down the flight of stairs, landing on top of them. Fortunately, no one was harmed.

One of Windsor's hardest-hit structures was the 127-year-old Poquonock Community Church. It lost its steeple, roof and front side. Reverend James Silver was in his office in the church behind the sanctuary. No one else was in the church buildings. He heard a noise unlike any he had ever heard before. Unlike the sound of a truck passing by, this noise didn't vary in pitch or intensity. He knew something was wrong. He knelt in the stairway, placing a jacket over his head. He heard the sound of glass breaking, then all went silent—the noise just stopped. Silver went downstairs and saw no damage.

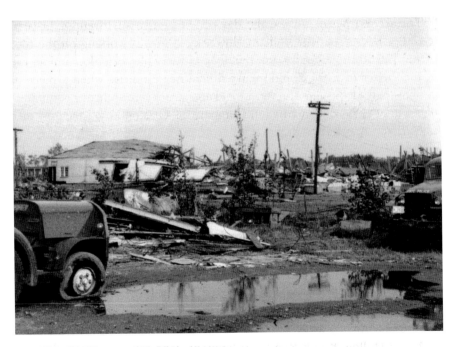

A yard of wreckage in Windsor Locks as it was left by the October 3, 1979 twister. *From Chip Carey, Windsor Locks/Windsor Locks Historical Society.*

Going back upstairs, he opened a door that led into the sanctuary and was shocked. There was a huge hole in the roof, and rain was pouring in. Glass had blown into the church and was everywhere.

Then, the sun came out. A volunteer fireman appeared and asked the minister to "go over to the school and make sure everybody is OK there." He did and found a Girl Scout troop inside. Fortunately, all were fine. He proceeded to walk down Hollow Brook Road and stopped at homes to check on people. Some houses were no longer on their lots—they had been lifted by the twister and carted across the street.

For fifteen minutes, Reverend Silver walked around the neighborhood alone. No rescuers had arrived yet. He thought to himself, "So nobody knows what has happened." In the days before cellphones, it was likely that the authorities were unaware of the devastation in a neighborhood only seconds away from Route 75. All of a sudden, a bulldozer arrived, followed by police officers, firefighters and other rescue personnel. Apparently, they had been detained at the bank, where one man had been killed and another fatally injured. Also, they had needed to shut down the power to the stricken neighborhoods so fallen electric cables could be removed and repaired.

After helping to the best of his ability, Reverend Silver started up his car, which was filled with glass from the windows being blown inward. One memory that has stayed with Reverend Silver for over thirty-five years occurred when he was driving slowly back home.

The "Glassy Stares"

As he drove up to and over the Farmington River Bridge (some traffic was allowed in the southward direction), men with briefcases were walking over the bridge the other way. The authorities had stopped all northbound traffic, and the men were required to park their cars on the south side of the bridge and walk home. They had spent the day working in Hartford and other places south of Windsor. Silver remembers the expressions on their faces, the "glassy stares" as they headed home, not yet knowing how their families had fared. Reverend Silver thought, "What are they going to find?" Undoubtedly, most, if not all, had no idea if their homes had been destroyed and their families injured or killed.

The Bible used in church services had been left on the pulpit of the Community Church. After the tornado, it was located in the back of the

The Reverend James Silver leading his congregation in an open-air service on the site of the damaged Poquonock Community Church. *From Jane Brown's collection.*

church under a lot of debris. A parishioner found it and asked Pastor Silver, "Had you opened it to this page?" Told he hadn't, the man held it up and said, "Well look and read this." It was open to Ezra 5:11. It reads, "We are the servants of the God of heaven and earth, and we are rebuilding the house that was built many years ago, which a great king of Israel built and finished."

The week before the tornado, Reverend Silver had announced from the pulpit that the trees in front of the church had grown to the extent that the church couldn't be seen from the street. Thus, he would need to have many cut down. One man in the congregation loudly announced, "No way! Trees are God's gift. You cannot cut down any trees!" Reverend Silver replied that he would schedule a meeting to discuss the matter. Five days before the meeting's scheduled time, the tornado destroyed sixty-seven of the sixty-eight trees. The sole remaining tree, a maple, was missing a limb. "We need not have a meeting," said Reverend Silver. "The Lord has decided."

After the storm, the Community Church took down the wall between two classrooms and held services there. Three months after the tornado, a windstorm blew down much of the church's south wall, which had survived the tornado. The falling bricks crashed through the sanctuary floor and into

the basement social hall. This additional damage necessitated the razing of the sanctuary and fellowship hall and the construction of a new building. In 1980, the Community Church's new sanctuary was dedicated and furnished with the surviving art deco windows from the old church.

After sweeping through Windsor, the tornado funnel headed north along Route 75 toward the Windsor–Windsor Locks town line, which is only a couple miles away from the Community Church. Just north of the line, directly in its path, stood Bradley International Airport.

As it swept north, the twister wrecked Dale Drug Store in Windsor Locks, wiping away half of its upper-floor apartment. A woman hid in the closet. After the storm, she was left without an outside wall. One of the first police officers on the scene was seen standing in front of the drugstore. He was heard repeating, "Everything's gone."

In Windsor Locks, storm winds removed most of the roof of the Koala Inn next to the airport, revealing twenty-four rooms with their furnishings intact. From the air, it looked like a bizarre dollhouse. It's said that the inn's alarm system was the first way Windsor Locks authorities were notified of the tornado.

One Windsor Locks business owner later said it got very dark and then winds whipped debris in circles, and cars were thrown thirty to forty feet into the air. A piece of one vintage plane ended up in his front yard. Not far away, Musco's Texaco station was destroyed.

AIRCRAFT THAT SURVIVED COMBAT SUCCUMB TO THE TORNADO

With winds of about two hundred miles per hour, the tornado swept by Bradley International Airport, coming close to the facility's eastern runway and toppling five radio towers. It demolished the adjacent twelve-year-old Bradley Air Museum, destroying its headquarters—a hangar from World War II—and damaging approximately twenty historic aircraft within it.

A quarter of a mile south of the hangar, the museum had about thirty more aircraft on outdoor display. Most of those planes were positioned to face northwest so as to best protect them from hurricane winds. It didn't help at all with the rotating funnel of a tornado. Only about five out of thirty aircraft stationed outdoors survived the winds.

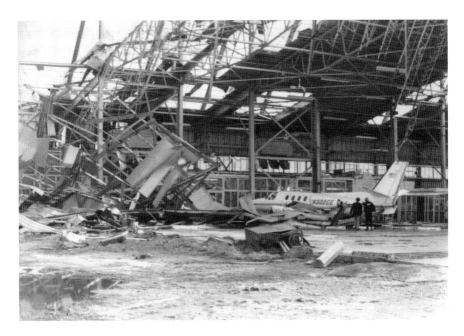

A destroyed aircraft hangar at the Bradley Air Museum. *From Chip Carey, Windsor Locks/ Windsor Locks Historical Society.*

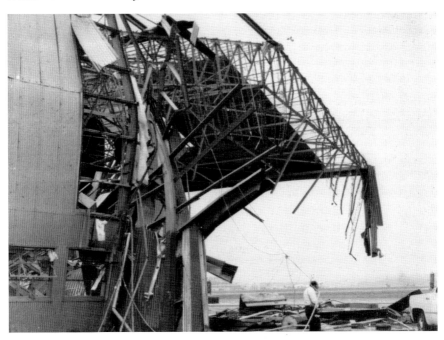

The edge of the hangar roof at the Bradley Air Museum. The hangar was not salvageable. *From Chip Carey, Windsor Locks/Windsor Locks Historical Society.*

Several years after the tornado, an article in the *Windsor Journal* stated, "The Bradley Air Museum looked more like Pearl Harbor, with battered and mangled aircraft strewn all about in twisted, contorted fashion." The museum's clock was stopped at 2:56 p.m., the time the winds hit the headquarters.

The Connecticut Limousine Service building at the airport was destroyed. One mile away from the tornado's path, in an airport parking lot, people found it impossible to open their car doors because of the pressure of the winds.

After leaving the airport, the twister did little additional damage in Windsor Locks and headed north to Suffield, where it touched down a few times but fortunately hit only farmlands. In total, the twister traveled about four miles and was usually one-fourth of a mile wide, but it killed two people on impact and sent two hundred to the hospital, a number of them in critical condition. Additionally, seven hundred people were rendered homeless within minutes.

Within twelve hours of the tornado, three hundred people had been treated for injuries. Throughout the cleanup efforts, Emergency Medical Services provided first aid to volunteers for puncture wounds, falls, cuts, bee stings and minor injuries.

Of the critically injured victims, the adults were taken to area hospitals, which included Hartford Hospital, Mount Sinai Hospital and St. Francis Hospital. A ten-month-old boy was sent to the Springfield Unit of Baystate Medical Center. All of those injured survived except thirty-seven-year-old construction worker Michael Vendette of Manchester. Having sought shelter in the truck with the second victim, William Kowalsky, he was seriously injured and passed away four days after the storm.

The final tornado toll included three fatalities and more than a dozen people critically injured. One victim was a sophomore at Windsor Locks High School who was sitting in a truck near the airport when the tornado dropped an airplane on her vehicle. She needed eleven hours of surgery to remove a blood clot from her brain and to repair a damaged artery. She was hospitalized for two months.

Another victim, twenty-year-old Brian Slupecki, spent six months in a coma in Hartford Hospital. He had been driving his van on a Bradley Airport service road when the tornado winds ejected him from the vehicle. After he regained consciousness, he had no memory of the tornado. Slupecki was treated at the world-renowned Gaylord Hospital, which is located in Wallingford, Connecticut. Coincidentally, the hospital is only a few minutes away from the location of the Wallingford tornado.

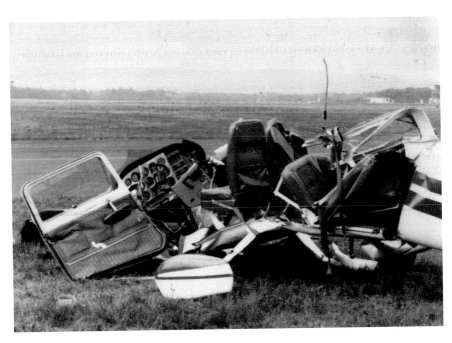

A small plane that was no match for the Windsor–Windsor Locks tornado. *From Chip Carey, Windsor Locks/Windsor Locks Historical Society.*

President Jimmy Carter designated the towns as a disaster area, which allowed home and business owners to obtain low-interest loans from the Small Business Administration, as well as apply for special federal disaster unemployment assistance.

Rescue efforts in Windsor and Windsor Locks were hindered by the fact that Connecticut Air National Guard helicopters at the airport were hit by the tornado winds. Bell helicopters, two Sikorsky S-64 Skycranes and two airplanes were severely damaged.

For days, the Windsor residential neighborhoods were filled with the sound of chain saws and the "beep, beep, beep" of heavy moving equipment. Thousands of trees and branches needed to be cut up. Many people both near and far volunteered to assist the community, including a group of Amish men who had traveled from Pennsylvania to help the victims.

While the Community Church suffered the brunt of the tornado, the nearby St. Joseph Catholic Church was unharmed. However, its cemetery was badly hit; grave markers were pushed over or thrown into nearby woods. A tall crucifix's Christ figure lost its arms and legs. A sign was found in St. Joseph's Cemetery after the storm. It read, "St. Mary's Cemetery." It had

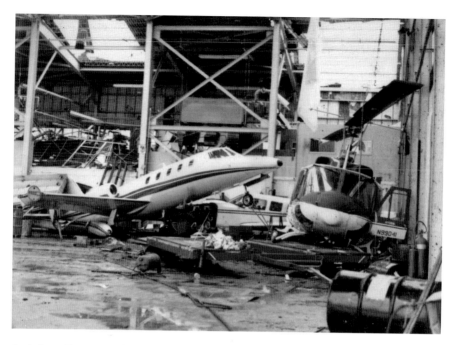

An indoor display of aircraft at the Bradley Air Museum. *From Chip Carey, Windsor Locks/Windsor Locks Historical Society.*

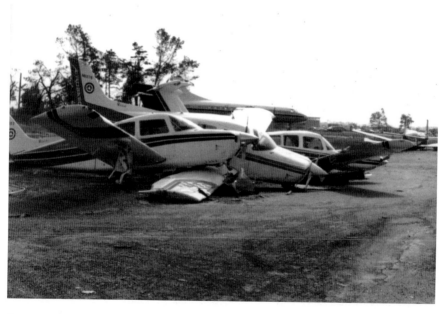

Destroyed aircraft at Windsor Locks. *From Chip Carey, Windsor Locks/Windsor Locks Historical Society.*

been blown from St. Mary's Catholic Church's cemetery in Windsor Locks, about two and a half miles away.

Connecticut governor Ella Grasso provided temporary housing in the form of twenty-seven three-bedroom mobile homes to residents who lost their homes. They arrived the Tuesday after the storm, and another twenty-five units followed. A week after the storm, one homeless couple complained in the local newspaper that people were being misled by the media, and the trailers were not free—they would come out of insurance policy payments and, if they were used up, out of loans. Apparently, the couple did not blame the governor, as they praised Grasso's personal efforts, as well as those of the Red Cross and the Salvation Army.

Governor Grasso was no stranger to natural disasters. Two years earlier, she had attracted national attention for her superb handling of one of the worst snowstorms in Connecticut history. She took a personal interest in the 1979 tornado, partly because she herself was a Windsor Locks resident. A story in the *Hartford Courant* mentioned that a woman telephoned from North Carolina trying to reach her son in Windsor Locks. The governor tracked him down and ascertained that he was safe and well. She told him, "Call your mother. She's worried sick about you."

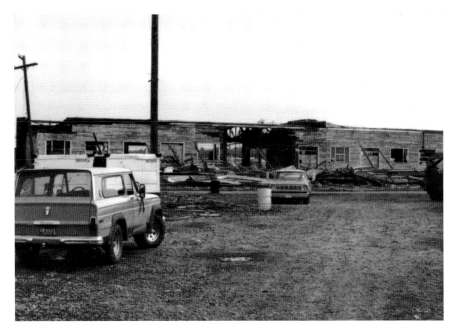

A building gutted by the Windsor–Windsor Locks tornado. *From Chip Carey, Windsor Locks/ Windsor Locks Historical Society.*

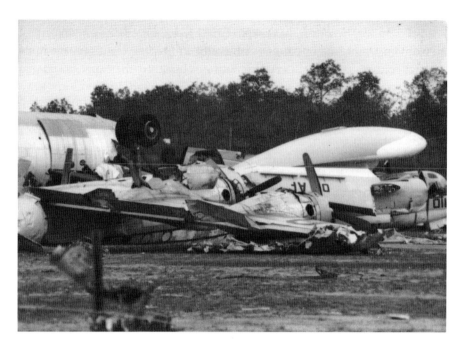

A clutter of large planes at the Bradley Air Museum in Windsor Locks. *From Chip Carey, Windsor Locks/Windsor Locks Historical Society.*

Although it caused only three deaths, the Windsor–Windsor Locks tornado ranked as one of the three most deadly in Connecticut; it could have been much worse.

THE GREATEST NATURAL DISASTER IN CONNECTICUT HISTORY AVERTED

Shortly before 3:00 p.m., United Airlines Flight 220 nonstop from Chicago was descending from its flying altitude of thirty-three thousand feet. The Boeing 727 passed through torrential rain and wind as it neared Bradley Airport. According to a study by meteorologist John Hales of the National Severe Storms Forecast Center, radar did not detect the tornado because it hit too close to the airport and was within low-rushing clouds and heavy rain.

Making a final approach from the southwest, the jet was piloted by Captain George F. Deihs, a former army pilot with almost twenty-five years of flying experience at United. Flight 220 had 114 passengers and 6 crew members.

As Flight 220 descended to two hundred feet on its approach to Runway 6, Captain Deihs was on his own—literally on his own—as everyone in the airport control tower had fled. Visibility was horrible; the experienced pilot needed to rely entirely on instruments, and Deihs made the decision to get out. He implemented an alternate procedure, pulling the aircraft's nose up and opening up the throttles.

When the plane rose, it was violently shaken by the storm. One passenger was later quoted as saying, "All of a sudden, every person in the plane was very, very still. It is very difficult to be noisy when you are praying."

As the plane circled the airport, passengers and crew on the right side could see the tornado. Without the benefit of air traffic control at Bradley, Captain Deihs contacted Boston and flew to Newark International Airport in New Jersey. It was determined later that if Flight 220 had landed as scheduled at Bradley, the plane could well have been destroyed. As it was, dozens of aircraft at Bradley and the adjacent air museum were demolished or severely damaged.

Within an hour of the tornado, police officers and firefighters from the surrounding towns—as well as from Enfield, Vernon, Somers and other municipalities—were already helping out in the tornado-stricken areas. Local, state and federal disaster relief officials set up offices at Poquonock Elementary School. Others authorities set up their headquarters at the Fire and Police Building in Windsor Locks.

Shelters were established at Windsor High School in Windsor and at the Union School in Windsor Locks. However, most people chose to accept offers of shelter from family and friends or to stay at Hartford-area hotels. Windsor mayor Warren Johnson said more local homeowners offered shelter to victims than was needed.

Over $200,000 was raised for the tornado relief fund. Companies and individuals contributed generously. The Hitchcock Chair Factory donated $15,000 worth of mattresses and box springs, which were delivered by the Salvation Army.

As in most tornadoes, personal accounts are filled with stories of one person's house receiving little or no damage while a neighbor's home was totally destroyed—stories of one group of trees being uprooted while bushes and trees several feet away were left unscathed. After touring the tornado's damage, Governor Grasso commented, "I have never seen that kind of damage. I've only seen it on television, and here it is happening to my neighbors."

Trespassers Use Metal Detectors

The night following the storm, sixty police officers were stationed in the stricken areas to prevent looting. In the days following the storm, the Connecticut State Police arrested eight people, most for violations of curfew. In the weeks after the storm, reports circulated of people who were found cutting wood without permission on the property of tornado victims, along with trespassers who had metal detectors and were combing properties for valuable items that might have been blown from the destroyed or damaged houses. After five attempted burglaries at the mobile homes, the Windsor Police Department instituted a crime prevention program for the disaster area that included trailer locks and a variation of the block watchers program.

After a review of the area by Windsor town planner Mario Zavarella and civil defense volunteers, the final numbers were totaled up: sixty-four buildings destroyed (forty-three of these private homes), fifty-eight structures heavily damaged (including forty-four homes) and eighty-one buildings with lesser damage (seventy-one homes). In Windsor Locks, twenty buildings at Bradley Airport were damaged.

Soon after the tornado, local youth services employees began to research means to counsel disaster victims. Learning of the value of neighbor-to-neighbor support groups in the tornado-prone midwestern states, they adapted the methods to Connecticut. In the weeks following the Windsor tornado, sixty-two victims attended counseling sessions.

Five days after the tornado, St. Joseph's Church in Windsor was the site of victim Carole Dembkoski's funeral. Included among the attendees were Governor Ella Grasso, town officials and many people who had lost their homes. One neighbor of the deceased, standing outside the church after the services, probably spoke for more than a few present when she said, "I feel sick in my stomach."

The tornado ended up causing over $400 million in damages and, in addition to the fatalities, injured some people who would endure life-long suffering. The Monday after the tornado, about two hundred volunteers engaged in a twenty-four-hour-long cleanup campaign in Windsor, Windsor Locks and Suffield. Union volunteers contributed generously of their time. These included members of Local 559 of the Teamsters, Local 1230 of the Laborers Union and Local 478 of the Operating Engineers Union.

Construction companies donated $8 million of machinery for the effort. The headmaster of Loomis Chafee School sent busloads of about eight hundred students and instructors to a gully to assist in the removal of debris.

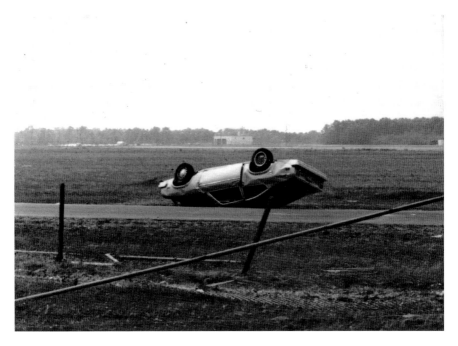

An upside-down car after the Windsor–Windsor Locks tornado swept through. *From Chip Carey, Windsor Locks/Windsor Locks Historical Society.*

Also among the volunteers were thirty National Guardsmen and four hundred Civil Preparedness volunteers. Of Connecticut's 169 towns, 100 offered the services of their police, fire and public works staff to Windsor and Windsor Locks.

The evening of the storm, the Windsor Public Works Department concentrated on reopening all roads to accommodate at least one-way traffic so emergency crews could reach the stricken areas. It also inspected the Farmington River Bridge for structural soundness and operated heavy equipment in the search for Carole Dombrowski. Later, the department switched to debris cleanup and removal, repairs to culverts and catch basins and preparation of the mobile home sites. On Saturday and Sunday, 600 and 1,200 volunteers assisted the town crews, respectively. The Sunday work included using a human chain to clear the Hathaway Hollow Ravine.

Crews soon removed all tree limbs and other debris. Then, new construction began. Within a year, even the most heavily hit streets were almost back to normal. One Pioneer Drive man who lost his home decided to prevent any future problems by rebuilding his replacement house half underground.

"Tourists Go Home"

Some cleanup efforts were hampered by the large number of sightseers entering the area to view the damage. Much of the debris was moved by truck to the Windsor Locks Sanitary Landfill, which is about six miles from Windsor's Poquonock section. The congestion of visitors meant the vehicles averaged only about twelve miles per hour. Some residents, irritated by the people slowly driving by as they were trying to clean their property, erected signs reading, "Tourists Go Home." Since the Wallingford tornado of a century before, modes of transportation had changed, but human nature had not. The *Windsor Journal* reported that the 1979 sightseers came from as far away as Pennsylvania.

In an incident reminiscent of the lost paper the Wallingford tornado carried to Rhode Island, a cancelled check from one of the demolished Settler Circle homes was blown fifty miles to the northwest into Massachusetts's Berkshire Mountains. A Peru, Massachusetts man found it the day after the storm while walking his dog. Later, in Peru and in a neighboring town, other Windsor papers were found: another cancelled check, pages from a history book and a cub scout membership card from Pack 256 in Windsor.

Meteorologist Ted Fujita, the creator of the Fujita Tornado Damage Scale, sent a research team to study the 1979 tornado. Another study was conducted by meteorologist John Hales of the National Severe Storms Forecast Center of Kansas City, Missouri. The path of destruction was only four miles long and the tornado's duration only five minutes, yet it was classified as an F4 tornado. According to the Fujita Tornado Damage Scale, an F4 levels "well-constructed houses" and throws cars. That certainly happened in Windsor and Windsor Locks.

The tornado was ranked as one of the eight strongest tornadoes in the United States in 1979, an incredible fact given that Connecticut has so few tornadoes compared to midwestern and southern states. Even more remarkable, at the time, it was ranked as the sixth most costly tornado in the entire history of the country.

After donations by individuals and businesses, the Bradley Air Museum rebuilt its collection of aircraft and exhibits. Today known as the New England Air Museum, it is the largest aviation museum in the northeastern United States. In 2014, Jane and Stanton Brown still run the family farm in Windsor with the help of their children. Tornado victim Brian Slupecki passed away in 2003 at age forty-three. Captain

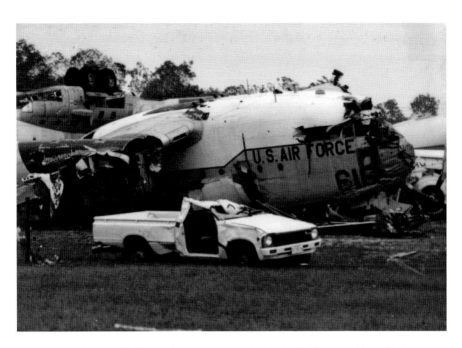

A huge United States Air Force plane was no match for the 1979 storm. *From Chip Carey, Windsor Locks/Windsor Locks Historical Society.*

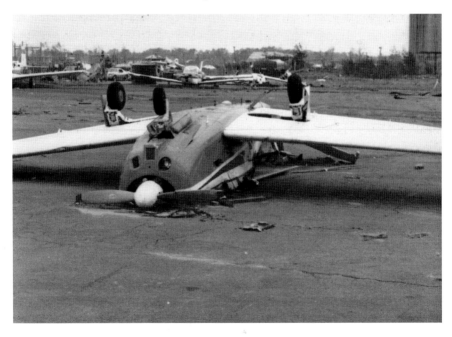

An upside-down single-engine plane after the 1979 tornado's winds hit. *From Chip Carey, Windsor Locks/Windsor Locks Historical Society.*

Deihs is retired and living in the Midwest. The Community Church's Bible is now on display in the front of the church, open to the page at which the tornado winds left it. In front of the church, the single surviving maple tree is still standing.

The 1979 Windsor–Windsor Locks tornado carried on the tradition of approximately one major Connecticut tornado per century. But if tornadoes have any common characteristic, it is unpredictability. The next giant Connecticut tornado wouldn't wait one hundred years; it would strike less than ten years later.

4
THE HAMDEN TORNADO OF 1989

A residential suburb of New Haven, Hamden had a population of about fifty-two thousand in 1989. Few of these people had experienced a tornado.

On Monday, July 10, 1989, a cold front dropping down from Canada encountered warm, humid air from the south, resulting in a powerful thunderstorm system forming over northern New York State. It moved through the Adirondack Mountains and down New York's Mohawk Valley. At 3:15 p.m., the National Severe Storm Forecast Center issued a severe weather watch for a broad area of the Northeast—northern New Jersey, southeastern New York and Connecticut.

At around 4:00 p.m., the storm entered the northwest corner of Connecticut, and in Cornwall, a tornado destroyed most of Cathedral Pines, a forty-two-acre stand of old-growth pine and hemlock trees. The twister traveled on, hit Litchfield County and destroyed a number of buildings in Litchfield's Bantam section, including a town hall, the Bantam Methodist Church and a post office.

STORM WINDS KILL

When the storm reached Watertown's Black Rock State Park, it killed a twelve-year-old Stratford Girl Scout. Her tent was crushed by a tree limb, which was blown down by storm winds. Two of her companions were seriously injured

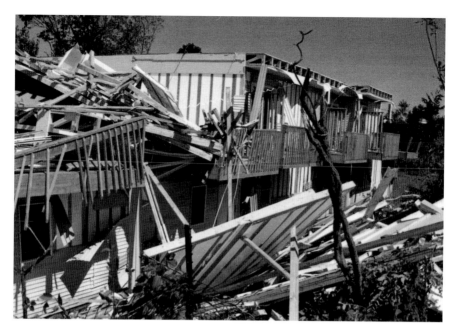

A new condo complex on the south side of Putnam Avenue, about one-tenth of a mile west of Newhall Street, after the 1989 Hamden tornado. *From the Hamden Fire Retirees Association. Photo by Hamden firefighters Raymond Dobbs and John Corbett.*

and sent to Waterbury Hospital. It was later determined that straight-line winds had blown the limb down, not the twisting, circular winds of a tornado. Another death attributed to the storm was that of a sixty-nine-year-old Watertown man who was struck by a heart attack as he viewed the damage.

The storm continued into Waterbury, where a second tornado formed and ripped off roofs and toppled countless trees. Surrounding towns experienced various effects of the storm system. Oxford, south of Waterbury, was hit with 4.4 inches of rain in one half-hour period.

Traveling at up to sixty miles per hour, the storm swept southeast to Hamden, arriving at about 5:30 p.m. There, it spawned another tornado—one far more powerful than the others.

The twister swept through the Highwood, Newhall and Whitneyville sections of Hamden and Newhallville in New Haven. Like the witnesses in Windsor a decade before, many in Hamden commented later on the sky's "pea soup" color just before the tornado hit.

"YOUR STORE IS GONE"

Georgia Ferraiolo and her husband were the owners of Ferraiolo's Fish and Meats on Dixwell Avenue, one of the main commercial streets running through Hamden and New Haven. In the late afternoon, they were eating at a restaurant in nearby West Haven. "It was beautiful out," recalls Georgia. Then, she received a phone call: "Your store is gone." The couple left quickly and drove back to Hamden but couldn't get near their store because authorities had the area blocked off.

Although disturbed by the possibility that their business was damaged and possibly destroyed, they were consoled by the fact that the store was closed on Mondays and no customers or employees would have been on site.

When Georgia and her husband finally reached their store, they found that everything had been destroyed. The tornado had picked up the building and dropped it back down. She remembers, "The first floor ended up in the basement. We couldn't find the part of the roof that was in the back of the store. It was completely gone—we never found it." Nearby, they spotted a car on top of the second story of a house.

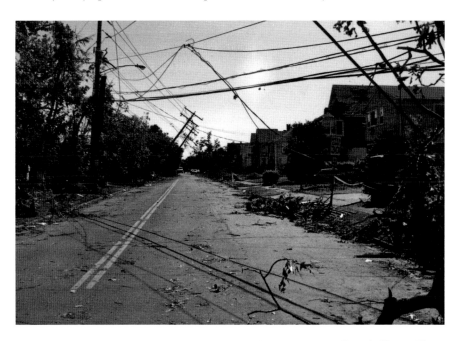

Putnam Avenue looking east from near the corner of Newhall Street. *From the Hamden Fire Retirees Association. Photo by Hamden firefighters Raymond Dobbs and John Corbett.*

Ronnie Ferraiolo, employed at his parent's store, was awakened by his wife, who told him, "You don't have to go to work today." Unable to get to the store, he drove his pickup to the top of Prospect Street, encountering trees "all over the place." Noticing a cast-iron bathtub that was stuck into a tree and another tree that had punctured the side of a brick house on Goodrich Street, he remembered that it was "like a war zone…like a nuclear blast."

Threw Man "Like a Line Drive"

One regular Ferraiolo's customer was running on a nearby football field when the storm came through. According to Ronnie, it rolled him into a fetal position, picked him up and threw him "like a line drive" across the field. He escaped with only a broken leg.

The tornado was also hard on many other Hamden small businesses. Among the other establishments destroyed on Dixwell Avenue were California Hair Designs and Senior's Kitchen. The Theroux Auto Body Shop on Putnam Avenue was a total loss. In seconds, the twister had converted it from a vibrant enterprise into a junkyard filled with wrecked office equipment and thirty-eight vehicles that had far more damage than when their owners had dropped them off for repair.

One couple who was at home at the time of the storm was Carol and Richard Bowes on Hamden's Putnam Avenue. At about 5:25 p.m., they heard a noise coming from the direction of their glassed-in porch. The wind was crushing the porch, and a tree fell against the front door. They tried to shut a window, but it wouldn't budge.

After they sat down on the floor with their dog, the whole house began moving around them. Richard said, "We have to get out of here." Carol objected, "No it's still storming." Richard asked, "Can't you smell gas?"

By this time, the window that they had tried to shut was now over their heads. Fortunately, they were able to "walk off" the front of the house. Neither of them was wearing shoes. They looked back at their home. The whole house had turned!

They proceeded to a neighbor's house and were given shoes, but that house smelled of gas, too. A second neighbor shouted, "Come up here; we're OK." After walking over, that person gave them a belt to use as a leash for their dog. By then, according to Carol, "The whole neighborhood reeked of gas." Richard's eyes began to bother him when plaster blew into them.

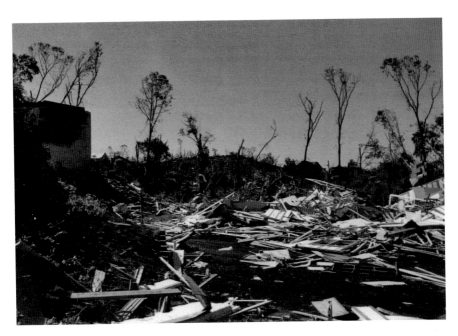

A new condo complex on the south side of Putnam Avenue after the storm. *From the Hamden Fire Retirees Association. Photo by Hamden firefighters Raymond Dobbs and John Corbett.*

In time, an ambulance arrived and took the Boweses to the Yale–New Haven Hospital emergency room. Carol remembers that, much to her dislike, she and her husband were split up. Carol was taken to have her neck and back X-rayed; Richard was taken for the evaluation and treatment of his eyes.

Later, when the Boweses were able to return to their home, they were amazed to see the bottom half of their hutch, along with a washbasin and its pitcher, intact. However, the top of the hutch had been taken by the tornado. It was never found.

In almost all cases of an imminent tornado, people are advised to go into their basements. However, as in most things, there are exceptions. Carol and Richard Bowes might well have been saved because they did the "wrong" thing. Because they didn't have time to get to their basement, they stayed upstairs and lay on the floor. Because of the freak way their house was tipped over, the basement was filled with water and gas. Carol explains that if they had gone down there, they "probably wouldn't have been able to get out." Because of the danger of explosions from gas leaks, Mayor John Carusone evacuated about one thousand residents in the area.

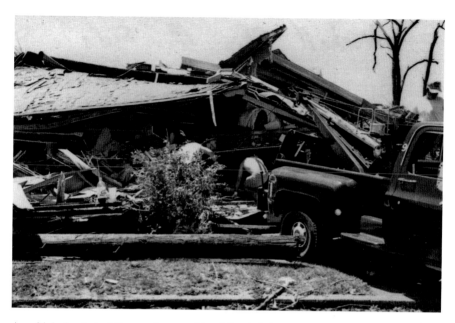

A multiple-family building on the west side of Newhall Street between Augur Street and Putnam Avenue. *From the Hamden Fire Retirees Association. Photo by Hamden firefighters Raymond Dobbs and John Corbett.*

When the tornado hit, the Hamden Fire Department's night shift was taking over from the day shift. The former had a hard time getting to work, and the latter had difficulty getting home. As the Hamden Fire Retirees Association website says, "It really didn't matter much anyway because before long all available fire personnel were being ordered to duty." The fire department, along with the police department and other authorities, did exemplary work both immediately after the storm and during the many days of cleanup and recovery.

"Air Was Stuffy—So Thick You Couldn't Breathe"

The Morgans of Augur Street in Hamden were also affected by the tornado. At the time, Debra Morgan was employed at a children's center on Whitney Avenue. On July 10, 1989, as she looked outside a window at home, the sky appeared like "pea soup." "This is bizarre," Debra thought. "The air was stuffy—so thick you couldn't breathe."

Debra also detected a burning smell in her house. To be safe, she unplugged all her appliances. Meanwhile, her dog was "going crazy." Looking out the back sliding door, she was amazed to see golf ball–sized hailstones. Even more surprising, the hail was flying by almost horizontally. However, she couldn't see far. Even though it wasn't yet six o'clock on a summer evening, the sky was "pitch black."

After closing the sliding door, Debra hurried to the basement with her dog. Once there, she could hear the wind whistling and glass breaking above her. The sounds grew worse, like trees cracking, and then the whole house began violently shaking. "This is the end of the world," she thought. Then, "just as quickly as it started, it stopped."

Upon going upstairs, she went to look out the window toward a neighbor's house. The woman there had a newborn baby. Debra couldn't see out the windows because trees and brush covered the sides of house. She called out to the woman but didn't receive a response.

Then it rained—not a drizzle but a heavy torrent of water. When it cleared, people from throughout the neighborhood gathered outside. They cried and hugged one another and did a count of who was there and—sadly—who was not.

Later, Debra discovered that the mother and her baby were safe. However, the woman had suffered a terrible fright—the tornado winds had blown into the house, and the force of the wind had prevented her from opening the baby's bedroom door during the tornado. As it passed, she opened the door, grabbed her baby and fled the house.

One house in the neighborhood still had a working telephone. Debra called her husband, who was twelve miles away in the town of Orange. "You need to come home," she cried. "We had a tornado!" At first, he didn't believe her, but then he hurried home. Later, Debra walked to her brother's house and described it as "like picking your way through a forest."

The Morgan house suffered relatively little damage—tops of trees hit the building, and glass was everywhere—but just three or four houses down the street, homes were pulled off their foundations. Perhaps the most striking damage on the Morgan property was an eight-inch by eight-inch by twenty-foot beam that dug a two-foot-deep hole in their yard. Later, it was determined that it came from the garage of large house on a nearby hilltop.

The Morgan house would have been in far worse condition but for Debra's husband's Blazer, which was parked in the backyard. It had its tires and glass blown out, but most importantly, its roll bar had stopped a huge tree from crushing the house. As Debra puts it, "The truck gave its life for my house."

They Wanted to See the Goriness and Blood

In the aftermath of the storm, one of the memories that sticks with Debra is the sound of chains rattling in the still of the night. They were the dog chains from the police service dogs as they (and the National Guard) paroled the devastated areas. Mayor Carusone had established a curfew in Hamden. Twenty Hamden police officers and eighty Connecticut State troopers patrolled Hamden on Tuesday night to prevent people from entering dangerous areas and to deter looting. No problems were reported with these precautionary interventions in place.

Debra remembers one big annoyance during cleanup efforts—the sightseers. They "wanted to see the goriness and blood." Those on foot wandered across lawns, peeked into windows and treated private property as if it were part of an amusement park. Those in cars caused gridlocks that hindered efforts to cut trees so that power could be restored. They disappeared only after police required people to show their licenses to get in and out of the area.

The Morgan family was one of the few in the area who stayed on their property. Initially, state police had asked residents to evacuate to the high school. Many did, and many went to stay with relatives and friends. The Morgans camped out. For ten or twelve days, they cooked their food outside on a grill and kept their drinks in coolers. Debra, who made spaghetti sauce outdoors, remembers the smell of garlic floating down Auger Street.

Interestingly, after the tornado had killed almost every tree in the neighborhood, residents seemed to have "felt naked." Everyone began to put up fences. Also, for years afterward, no birds were heard, nor were squirrels seen running around the area. Without trees to support them, they went elsewhere.

One humorous incident occurred in the Augur Street neighborhood. One resident owned an excavation company and, thus, was able to obtain the workers and materials to do an immediate cleanup and repair job. In less than two days, all trees, stumps, brush and other debris on his property was cleaned up, while adjacent lots were still in shambles. His house was repaired, and even a new walkway was put in. When Connecticut governor William O'Neill toured the area a couple days after the tornado, he was amazed to find one immaculate property amidst dozens of wrecked and debris-covered lots. According to Debra, it was as if that property had been in "a magical bubble."

Thinking back over her experience, Debra Morgan is absolutely sure that she would not want to go through another tornado. Emphatically, she exclaims, "Once is enough!"

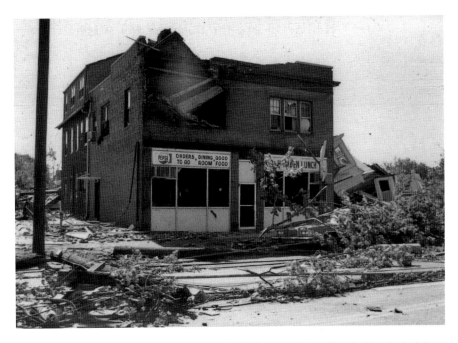

A Hamden Lunch building. *From the Hamden Fire Retirees Association. Photo by Hamden firefighters Raymond Dobbs and John Corbett.*

In Hamden, over 150 houses and business structures were destroyed within minutes, utility poles were toppled, thousands of trees were uprooted or broken apart and cars were crushed by trees and other debris. A sixteen-unit townhouse condominium was among the hardest-hit structures. One man described the accompanying hail as falling like ice cubes; others experienced hail as large as tennis balls.

The stories of survivors traveled through the town and beyond. In Hamden, a four-year-old boy was sucked out of a window, and a three-year-old girl received a neck injury when a house fell on her. Thankfully, both children recovered.

Years later, Hamden mayor Carusone was quoted in the *Register* as saying that every utility pole in the Highwood section "was shaved four feet from the base as if a scythe cut them." He went on to remember that Rochford Field "was filled with blood" as it was being used for a triage station for people injured by broken glass.

A total of five square blocks in the Highwood section of town were destroyed. Immediately after the tornado, fire rescue crews from Hamden and surrounding towns raced to the scene of the damage. Coast Guard helicopters also were used to search for survivors.

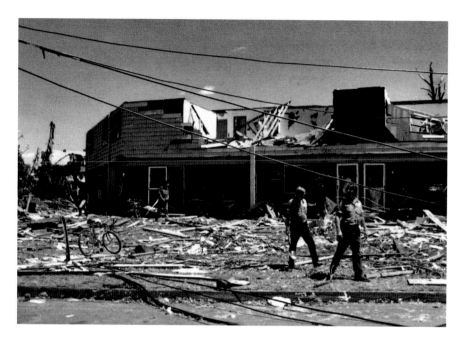

Newhall Street at the corner of Auger Street. *From the Hamden Fire Retirees Association. Photo by Hamden firefighters Raymond Dobbs and John Corbett.*

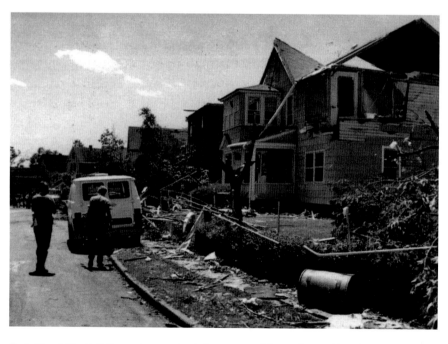

East side of Newhall Street, just north of the corner of Auger Street. *From the Hamden Fire Retirees Association. Photo by Hamden firefighters Raymond Dobbs and John Corbett.*

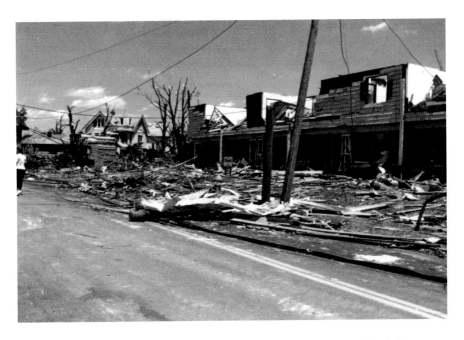

East side of Newhall Street at the corner of Auger Street. *From the Hamden Fire Retirees Association. Photo by Hamden firefighters Raymond Dobbs and John Corbett.*

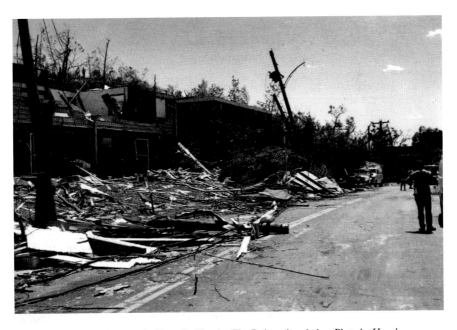

Newhall Street looking south. *From the Hamden Fire Retirees Association. Photo by Hamden firefighters Raymond Dobbs and John Corbett.*

The New Haven C-MED emergency medical dispatch service treated 121 storm injuries in the hours after the tornado, Yale–New Haven Hospital treated 37 and the nearby Hospital of St. Raphael saw a dozen more. Twenty miles away, 27 people were treated at Waterbury Hospital.

About one thousand residents of New Haven's Highwood section were evacuated. Four hundred homes and commercial properties were ruined, and scores of traffic signals needed to be replaced.

The evening of the tornado, about one hundred people sought shelter in Quinnipiac College dormitories or at Hamden High School, which was just north of the heart of the devastation. Others were put up at the Howard Johnson Motel on Whitney Avenue and at Hamden Village, a senior citizen housing center.

Governor O'Neill declared Hamden a disaster area. Parts of seventy roads and streets in New Haven and Hamden were closed until work crews could repair power lines and remove debris from houses and streets.

The Force of Niagara Falls

After leaving Hamden, the tornado mowed through a section of northern New Haven. At Albertus Magnus College, whose fifty-acre campus straddles the border of Hamden and New Haven, a metal roof from the athletic center's new multimillion-dollar gymnasium was ripped off. The building was a mere two days away from completion.

As pieces of the roof were scattered across the campus, the torrential rain permanently damaged the ceiling and floor. Fortunately, no one was injured at the school. Not far away, Wilbur Cross High School's gym floor was also damaged by flooding.

Economics professor Sister Charles Marie Brantl, who was living on the Albertus Magnus College campus, recalled her experiences:

> By the time I reached the second floor [of her residence] the winds and rain were so strong that lamps had blown off tables and loose items were flying around the rooms. The noise was deafening. The rain slashed against the house with the force of the falling waters of Niagara Falls. Hail stones hit against the windows. Yet within five to ten minutes there was complete silence. The storm was over; devastation was left behind.

It's interesting to note that over one hundred years earlier, medical doctor Benjamin Harrison had used the same Niagara Falls comparison to describe the Wallingford tornado. One thing that was different between the two storms was that, in 1878, Dr. Harrison had described the sound of the tornado as being like a locomotive, while in the 1979 and 1989 storms, many witnesses compared their twisters' sounds to jet engines.

Most of the buildings on the Albertus Magnus campus suffered damage from the tornado, and two hundred trees, some well over a century old, were uprooted. The damage at nearby Yale University wasn't as noticeable, but it still amounted to about $1 million worth. The tornado left behind a revolving door that was blown out of its socket at the Kline Biology Tower, Yale University's tallest building.

"I Do Not Scare Easily, but I Was Extremely Afraid"

Sister Brantl ended her account of the New Haven part of the storm thusly:

I personally have been through five or six severe hurricanes in my life, but none of these compares to the experience of this storm. I do not scare easily, but I was extremely afraid as I went from window to window trying to lower it or pull it back in. The area had become so dark, the lights had gone out, the winds and the rains were of unbelievable force. The remarkable thing is that no one in the New Haven/Hamden area was killed and the injuries were few and not serious. The Lord is indeed our refuge and help in time of storms and devastation.

Many people were unaware of the tornado. For Dr. Julia McNamara, the president of Albertus Magnus College, it had been a beautiful, sunny day, and she was enjoying a movie at the Showcase Cinemas in Orange. Halfway through *Dead Poets Society*, the film abruptly stopped. The manager came into the theater and apologized; power had been lost, and all monies would be refunded.

Returning to New Haven, Dr. McNamara entered the Connecticut Turnpike, which was stop-and-go traffic all the way. As she took back roads, the sky ahead became "like night." However, bright sunshine still appeared over the waters of Long Island Sound.

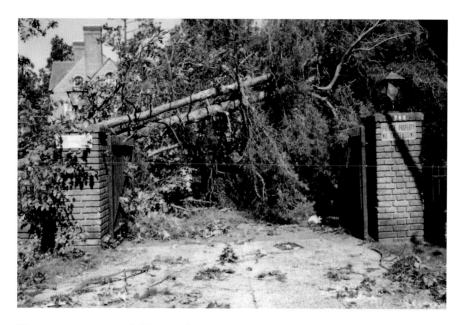

The entry gates at one of Albertus Magnus College's buildings. *From the Albertus Magnus College Library collection.*

Stopping at a restaurant on Wooster Street for a late dinner, she was about to order when the mayor of Hamden approached her table. "Julia, do you know what happened on Prospect Street?" Admitting she did not, he continued, "There's been a terrific storm. There's a lot of damage to buildings and trees."

Dr. McNamara left immediately and headed toward the campus. Debris was everywhere. She was obsessed with one thought: "Was anyone hurt?" She knew night classes had been scheduled to meet earlier in the evening. As she approached the campus from the east, she was stopped by a state police officer, who declared, "You can't go up there. There are trees everywhere." After explaining her reasons, the officer relented and told her she could continue but admonished her to "be careful."

As Dr. McNamara headed up Prospect Street, she was amazed by the hundreds of trees that had been uprooted. Near the president's house, every oak tree was on its side with its entire root system sitting above the ground. Fortunately, evening classes weren't scheduled to start until 6:00 p.m., and almost everyone had heard that the campus was off-limits. Those who were unaware of class cancellations soon found themselves returning home because of impassable roadways. Today,

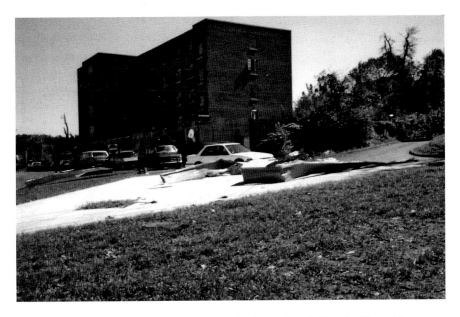

Pieces of the Albertus Magnus College gymnasium's metal roof. *From the Albertus Magnus College Library collection.*

Albertus Magnus College (like most other schools) has a technologically sophisticated emergency contact system to relay important notifications by telephone, text and e-mail.

The most severely damaged campus building was the athletic center. The only person inside it when the tornado hit was Athletic Director Tom Blake. Fortunately, he was not hurt. Later, he told President McNamara that it had been like a huge train racing through.

After leaving New Haven, the storm system crossed Long Island Sound and hit Port Jefferson, Long Island. At 7:15 p.m. at Spadaro Airport in East Moriches, Suffolk County, Long Island, a trailer was lifted and dropped in pieces on the airfield. A man who had been inside watching television sustained only minor injuries. Nearby, a small plane was pulled off the runway and deposited one hundred feet away in the adjacent woods.

Earlier, in Putnam County, New York, a tornado had damaged seventy-five condo units in Carmel and about fifty homes in Brewster. At 7:30 p.m., another tornado attacked Fort Lee, New Jersey, which lies near the George Washington Bridge. It left a quarter mile of destroyed trees.

Dr. Mel Goldstein: "The Worst Storm I've Seen"

Famed meteorologist Dr. Mel Goldstein, director of Western Connecticut State University's Weather Center, stated, "This is the worst storm I've seen in twenty years of forecasting." Connecticut damage was estimated at between $125 and $200 million; about half of that was in Hamden.

Like the Wallingford tornado, the 1989 storm ravaged some of the poorest neighborhoods in southern Connecticut, as well as middle-class areas. Hundreds were left homeless in Hamden and New Haven. Fortunately, the 1989 twister did not leave the same monstrous death toll as the 1878 tornado.

In the aftermath of the twister, people from undamaged areas of New Haven and Hamden were amazed by the destruction since they had only experienced a heavy rainstorm. Until they heard the TV and radio accounts, they never suspected that one of the worst tornadoes in Connecticut history had hit a few blocks away.

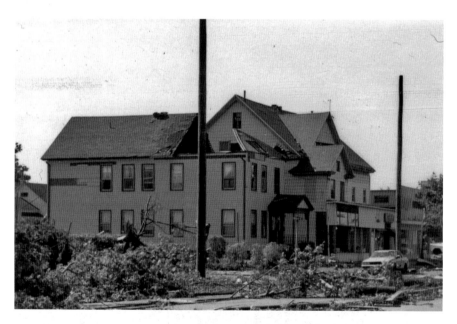

The east side of Dixwell Avenue, just south of Dudley Street. *From the Hamden Fire Retirees Association. Photo by Hamden firefighters Raymond Dobbs and John Corbett.*

Opposite, bottom: Leeder Hill Road near H.A. Leeds (now LHI Architectural Aluminum Products Division Industries, Incorporated). *From the Hamden Fire Retirees Association. Photo by Edward Doiron, Jr.*

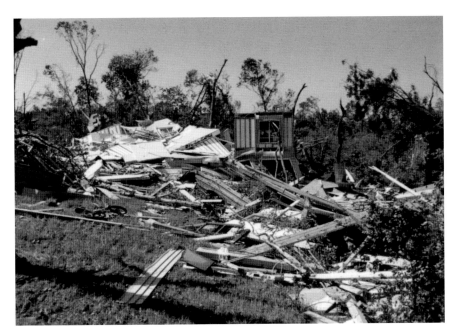

Part of the remains of a new condominium complex on Putnam Avenue, about one-tenth of a mile west of Newhall Street. *From the Hamden Fire Retirees Association. Photo by Hamden firefighters Raymond Dobbs and John Corbett.*

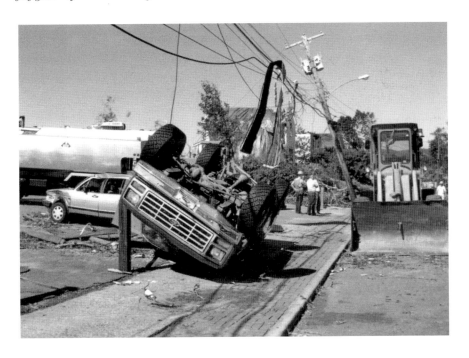

As the air was filled with the sounds of heavy equipment clearing innumerable broken and uprooted trees and pieces of houses and stores, some folks found ways to help their neighbors. Employees at the Dixwell Avenue Subway restaurant grabbed a shopping cart and distributed free grinders and drinks to the folks on Newhall Street.

In an example of business acumen reminiscent of Dan O'Reilly's refreshment stand after the Wallingford tornado, four pre-teen New Haven girls set up a grape and orange juice stand on Livingston Street next to a large maple that had been uprooted by the storm.

In Bantam, firefighters and about one hundred Connecticut Lions Club volunteers worked to clean up the debris. A tornado relief fund was started, and it promoted T-shirts reading, "Bantam Will Rise Again," and sporting a bantam rooster.

"More Like What We See in Kansas and the Midwest"

Richard Kane, a National Weather Service meteorologist in Albany, New York, stated that this 1989 storm was "more like what we see in Kansas and the Midwest. If we were out in Kansas or Oklahoma, I think people would be a little more attentive." As we have seen, these comments could just as easily be applied to the cases of previous Connecticut tornadoes. The surprise felt by the Robbins family of Wethersfield or the Mooneys of Wallingford must have been overwhelming. Most New England residents listen to weather warnings and alerts but take minimum precautionary measures unless they are in shoreline or flood zones.

According to the Town of Hamden's 1989–90 Annual Report, 24 houses were completely destroyed, 157 were "severely damaged" and five hundred trees were destroyed. The costs to the power company, United Illuminating, was $3.0 million and $35.0 million to private property owners. The Federal Emergency Management Agency (FEMA) gave Hamden $7.3 million to repair Hamden Middle School and $4.5 million to repair other public property.

The end result of the 1989 storm in Connecticut: a total of 250 people were injured. The tornadoes in the Litchfield and Waterbury areas were deemed to be F2s, and the Hamden–New Haven twister was rated an F4. It joined the Wethersfield, Wallingford and Windsor–Windsor Locks tornadoes as one of the four most powerful twisters in Connecticut history.

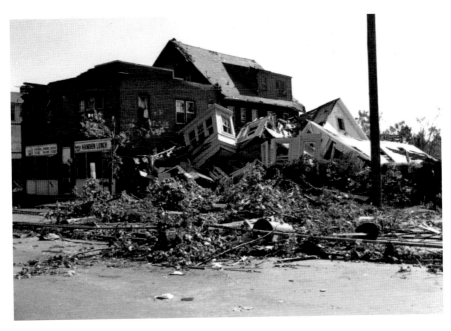

A collapsed house on the corner of Dixwell Avenue and Dudley Street. *From the Hamden Fire Retirees Association. Photo by Hamden firefighters Raymond Dobbs and John Corbett.*

In the twenty-five years since the Hamden disaster, no other tornado has approached its power. Undoubtedly, another F4 twister will someday hit Connecticut. Hopefully, it will not be in a highly populated area.

CONCLUSION

It's a relatively little-known fact that the United States is the tornado capital of the world, with an average of about 1,250 tornadoes per year. No country on earth has had a greater number of incidents of this type of storm. Sometimes other countries have more tornado-related fatalities, but that is due to population concentration, not the number of the storms. Even in total deaths, the United States often ranks higher than other countries. For example, in 2013, fifty-five people were reportedly killed by tornadoes in the United States, while fifty-eight such fatalities occurred in the rest of the world.

Although tornadoes leaving a great number of fatalities occasionally occur in the midwestern and southern United States, elsewhere in the Western Hemisphere, they are rare. In fact, in recorded history, only one tornado in the Western Hemisphere (outside of the United States) has killed more people than Connecticut's Wallingford tornado. That one, which occurred in Argentina in 1973, resulted in sixty-eight deaths.

One interesting coincidence relates to a tornado that struck New Zealand on December 6, 2012. It killed three people, tying a sixty-three-year-old record for the deadliest tornado in that country. The tornado's destruction was centered on a residential street in Hobsonville on which every house was damaged. Its name was Wallingford Way.

It's interesting to compare witness descriptions of the various tornadoes. As the Wethersfield tornado of 1787 ended its trek in the town of Coventry, a resident of that place, J. Huntington, stated that he heard "a loud and hoarse roaring, similar to what I have often heard in the woodland, near the

adjacent river, about two miles southwest from my house, but much louder than ever I heard before." In Wallingford in 1878, the survivors compared the tornado to the sound of a freight train. Most witnesses lived close to the railroad tracks, and it was undoubtedly the loudest sound with which they were familiar. In the 1979 and 1989 twisters, countless witnesses were reminded of the roar of jet planes or nuclear blasts as well as trains. Others found the sounds beyond comparison. Reverend James Silver of Windsor stated, "I never heard a sound like that before."

One of the most frightening aspects of the tornado is its ability to materialize with little or no warning. Meteorologist Geoff Fox told the author of this book, "Our ability to identify and track storms has gotten much, much better since 1989. We had radar, but not Doppler radar. Doppler can see wind within storm clouds. A tornado has opposing winds in close proximity. Nothing is foolproof, but Doppler radar is an amazing tool for those few days a year when there is tornado potential." (Fox has been so impressed by the value of Doppler radar that he even named his dog Doppler!)

He went on to say, "Forecasting is better, too, but we still have to warn too large an area. There just isn't enough accuracy to forecast storms in one town but not another. Often, a watch will go up statewide for a system which ends up bringing one or two cells of concern."

Looking back at the tornadoes of 1787 and 1878, we can appreciate the improvements in technology that have given people in the twenty-first century a better chance of protecting themselves from these types of storms, and we can hope for the day when the surprise tornado becomes a thing of the past.

BIBLIOGRAPHY

INTRODUCTION

U.S. Department of Commerce, National Oceanic and Atmospheric Administration. "U.S. Reported Tornadoes and Average Number of Deaths per Year 1961–1990." N.p.: National Weather Service, n.d.

1. THE WETHERSFIELD TORNADO OF 1787

Dexter, Franklin Bowditch. *Biographical Sketches of the Graduates of Yale College: With Annals of the College History*. New York: Holt, 1885.

Hartford (CT) Courant. "The Great Hurricane of 1787." November 7, 1873.

———. "Hurricane Once, Now Fire Destroys." June 4, 1907.

———. "The 1787 Hurricane: Interesting Reminiscences Connected Therewith." August 17, 1887.

Lewis, J. "An Account of the Late Hurricane at Wethersfield." *Hartford Courant*, August 20, 1787.

Perley, Sidney. *Historic Storms of New England*. Salem, MA: Salem Press Publishing, 1891.

Stiles, Henry Reed. *The History of Ancient Wethersfield*. Vol. 2. New York: Grafton, 1904.

2. The Wallingford Tornado of 1878

Atwater, Francis. *Memoirs of Francis Atwater: Half Century of Recollections of an Unusually Active Life. Considerable Space Devoted to the Progress of the City of Meriden and Its People. Enterprises Organized in Many Places, Covering Varied Lines of Business*. Meriden, CT: Horton Printing, 1922.

Bevan, Anne, ed. *History of the Wallingford Police Department, 1913–1995*. Wallingford, CT: Wallingford Police Department, circa 1995.

Blythe, David R. *Establishment of the Wallingford Police Department*. Wallingford, CT: Wallingford Police Department, 2014.

Davis, Charles. *History of Wallingford, Conn. from Its Settlement in 1670 to the Present Time*. Meriden, CT: C.H.S. Davis, 1870.

Farrell, Gerald. *History of Wallingford: The Relationship Between Wallingford's Yankees and Immigrants*. VHS. Wallingford, CT: Wallingford Historic Preservation Trust, 1995.

————. *History of Wallingford: Wallingford's Irish Community—An Interesting Look at the Many Transitions of an Immigrant Community*. VHS. Wallingford Historic Preservation Trust, 1994.

Gannett, Henry, and Marcus Baker. *Topographical Atlas of the State of Connecticut*. Hartford, CT: State Librarian, 1893.

Gillespie, Charles. *Souvenir History of Wallingford, Connecticut, 1895*. Meriden, CT: Journal Publishing Company, 1895.

Hale, Clarence E. *Tales of Old Wallingford*. Chester, CT: Pequot, 1971.

Hartford Connecticut Catholic. "Wallingford's Woe." August 17, 1878.

Hartford (CT) Weekly Times. "A Cyclone." August 15, 1878.

———. "The Wallingford Sufferers." August 15, 1878.

Hart, Samuel. *Encyclopedia of Connecticut Biography.* N.p.: American Historical Society, 1917.

Hazen, Henry Allen. *Fact and Theory Papers: The Tornado.* New York: N.D.C. Hodges, 1890.

Hill, Everett G. *A Modern History of New Haven and Eastern New Haven County.* Vol. 1. New York: S.J. Clarke, 1918.

Kendrick, J.B. *History of the Wallingford Disaster.* Hartford, CT: Case, Lockwood and Brainard Company, 1878.

Meriden (CT) Morning Record. "Good Morning! Officer Daniel O'Reilly Many Happy Returns of the Day." October 29, 1914.

———. "How Wallingford Aided Worchester Tornado Victims." October 28, 1967, sec. B.

Morse, Eldridge, ed. *Snohomish (WA) Northern Star*, October 5, 1878.

Newell, Clara L., John R. Cottrill and Clifford Leavenworth. *A History of Wallingford, 1669–1935.* N.p., n.d.

New York Times. "Furious Northern Storms, Connecticut Village Devastated by a Tornado." August 10, 1878.

———. "The Ruin at Wallingford." August 12, 1878.

O'Brien, J.J. "Windermere Lake." *Wallingford (CT) Windermere Weekly Forum* 29 (June 1878).

O'Toole, John M. *Tornado!: 84 Minutes, 94 Lives.* Worcester, MA: DATA, 1993.

Phelan, John G. *A History of the Rise and Progress of Catholicism in Wallingford from the Exiled Acadians of 1756 to the Dedication of the Church of the Most Holy Trinity in 1887*. Wallingford, CT, 1887.

Rockey, J. *History of New Haven County, Connecticut*. Vol. 1. New York: W.W. Preston, 1892.

Taylor, William Harrison. *Legislative History and Souvenir of Connecticut, 1897/98– 1911/12. Portraits and Sketches of State Officers, Senators, Representatives, Clerks, Chaplains, Etc*. Putnam, CT: W.H. Taylor, 1897.

Two Hundred and Fiftieth Birthday Anniversary of Wallingford, Connecticut, September 4, 5, 6, 1920; Official Program. Wallingford, CT, 1920.

United States Army Signal Corps. *Annual Report of the Chief Signal-Officer*. Washington, D.C.: Government Printing Office, 1878.

Wallingford Historical Society. *Images of America: Wallingford*. Charleston, SC: Arcadia, 1999.

Wallingford (CT) Windermere Weekly Forum. "Whirlwind." May 25, 1878.

3. THE WINDSOR–WINDSOR LOCKS TORNADO OF 1979

Felson, Leonard. "Twister Victim Regains Consciousness." *Stamford (CT) Hour*, August 8, 1980.

Hartford (CT) Courant. "Another Storm Boosts Standing of Governor." October 8, 1979.

———. "Bureau Counseled 42 Families Affected by October Tornado." December 25, 1979.

———. "School Reconstruction Expected in June." December 17, 1979.

———. "Tornado Snowfall Made News." January 1, 1980.

———. "20 Years After Tornado Struck Bradley Survivors Recall Destruction." October 3, 1999.

New England Air Museum. "Tornado!" http://web.archive.org/web/19980710071633/neam.org/tornado1.htm.

Windsor (CT) Journal. "In Windsor Locks, Business Has Rebound." October 5, 1984.

———. "Massive Cleanup Begins." October 11, 1979.

———. "October 3, 1979: Tornado's Destruction Never to Be Forgotten." October 3, 1979, sec. 5.

———. "Those Trailers Are Not Free." October 11, 1979.

———. "Tornado Is Main News Item of 1979." January 3, 1980.

Winsdsor (CT) Journal Inquirer. "In the Air, Jet Barely Avoided Whirlwind." October 16, 1979.

———. "The 'Next Tornado'? Maybe 50 Years, Maybe Never." October 3, 1980.

Windsor Locks (CT) Journal. "Tornado Oct. 3, 1979." October 11, 1979, special ed.

4. The Hamden Tornado of 1989

Brantl, Charles M. *The Torrent Swept Over Us.* Typescript, Albertus Magnus College, New Haven, CT, 1989.

Donnelly, John. "Storms Hit East as Fires Ravage West." *Hudson (NH) Telegraph,* July 11, 1989.

Eugene (OR) Register-Guard. "Tornado Damage Assessed." July 12, 1989.

Hamilton, Robert A. "Holding On in Devastation." *New York Times,* July 16, 1989, sec. A.

Hays, Constance L. "Unusually Fierce Winds Razed 100 Homes." *New York Times,* July 12, 1989, late edition (East Coast), sec. B.

King, Wayne. "Our Towns; After Tornado, So Many Lives at a Standstill." *New York Times,* July 28, 1989, sec. B.

McQuiston, John T. "Girl Is Killed in Connecticut as Storms Batter the Region." *New York Times,* July 11, 1989, late edition (East Coast), sec. B.

New Haven (CT) Register. "In the Twister's Path—Memories of Destruction Linger 20 Years Later." July 5, 2009.

———. "Storm Toll Tops $52 Million." December 7, 1989.

———. "Toll: Storm's Cost May Top Hurricane Gloria." July 12, 1989.

———. "Tornado Smashes Hamden, Causes Major Damage in City." July 11, 1989.

New York Times. "The View From: Bantam: The Town That Determination Is Building Again." October 8, 1989.

Ravo, Nick. "Connecticut Residents Remember a Storm Worthy of a Nightmare." *New York Times,* July 13, 1989, late edition (East Coast), sec. B.

Shea, Jim. "The Fury of Wind." *Hartford (CT) Courant,* January 12, 2014, sec. A.

Worcester, W. "Three Songs and It Was Over." *Yankee* magazine, July 1990, 52.

CONCLUSION

Burnie (Tasmania) Advocate. "Tornado Kills Three, Leaves Hundreds Homeless in Auckland." December 6, 2012. http://www.smh.com.au/environment/weather/tornado-kills-three-leaves-hundreds-homeless-in-auckland-20121206-2awz8.html.

ABOUT THE AUTHOR

R obert Hubbard is an associate professor and the director of the computer information systems program at Albertus Magnus College in New Haven, Connecticut. He is the author of four other books: *Armchair Reader: The Last Survivors*, *Images of America: Middletown*, *Images of America: Glastonbury* and *Legendary Locals of Middletown*.